OPENING ZION

PHOTOGRAPHS

From left to right, Catherine Levering, Anna Widtsoe, Nell Creer, Mildred Gerrard, Stella Peterson (chaperone), Melba Dunyon, and Dora Montague are invited to open Zion National Park in 1920.

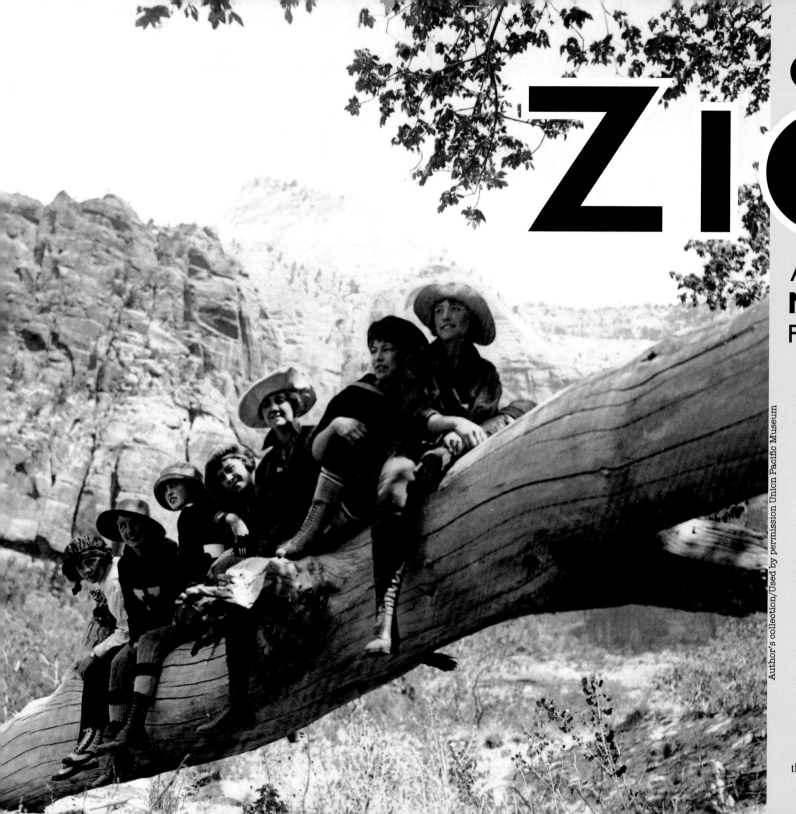

OPENING
ZION

A SCRAPBOOK OF THE
NATIONAL PARK'S
FIRST OFFICIAL TOURISTS

BY JOHN & MELISSA
CLARK

Bonneville Books
www.UofUpress.com *Salt Lake City*

A joint imprint of the University of Utah Press and
the J. Willard Marriott Library at the University of Utah

Bonneville Books
www.UofUpress.com Salt Lake City

The Bonneville Books colophon depicts a
Quetzalcoatlus, a giant pterosaur with a fifty-foot
wingspan. Courtesy of Frank DeCourten.

Bonneville Books is a joint imprint of The University
of Utah Press and the J. Willard Marriott Library at
The University of Utah.

Library of Congress Cataloging-in-Publication Data

Clark, John, 1970-
 Opening Zion, a scrapbook of the National Park's
first official tourists / John and Melissa Clark.
 p. cm.
 Includes bibliographical references.
 ISBN 978-1-60781-006-3 (pbk. : alk. paper)
1. Zion National Park (Utah)—History. 2. Zion
National Park (Utah)—Description and travel.
3. Zion National Park (Utah)—Pictorial works. I.
Clark, Melissa, 1968- II. Zion National Park (Utah)
III. Title.
 F832.Z8C57 2010
 979.2'48—dc22
 2009046506

Cover art by John Clark

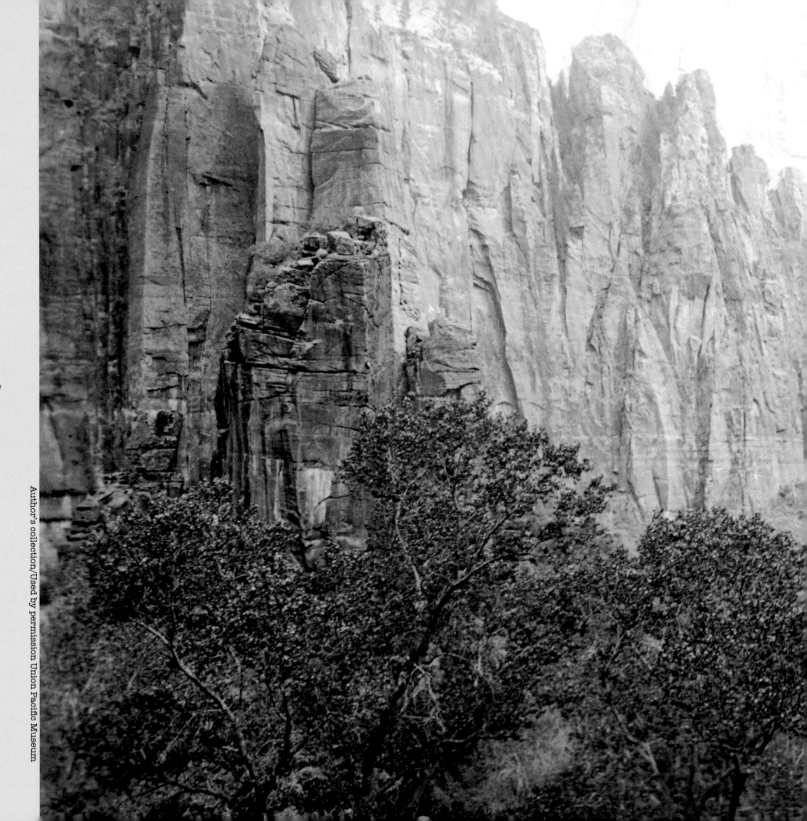

Author's collection/Used by permission Union Pacific Museum

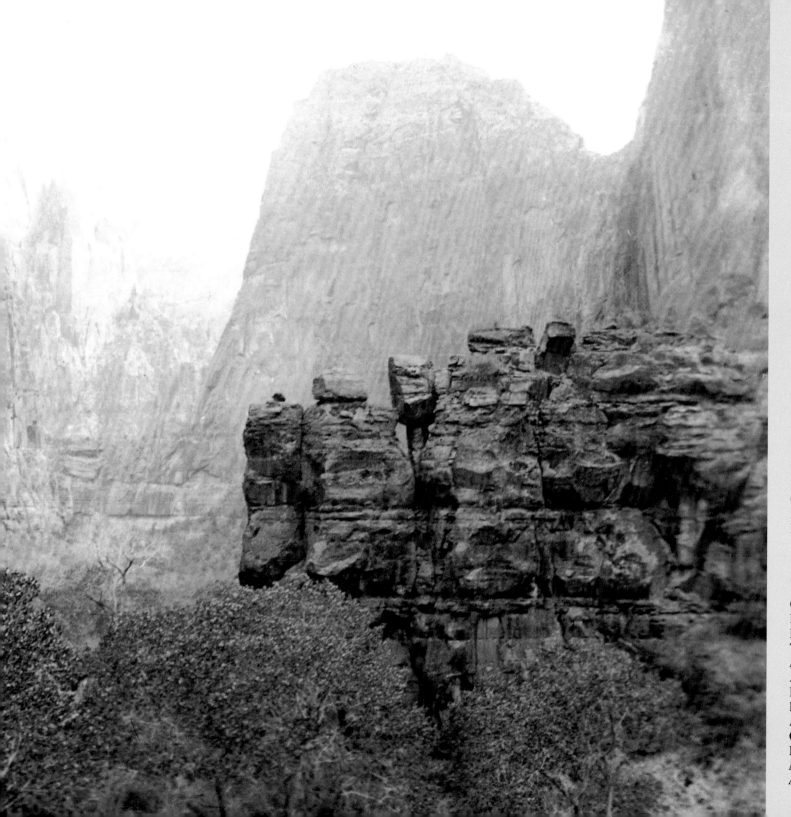

CONTENTS

Acknowledgments ...vi
Preface ...ix
Introduction ..xi

PART 1:
PROMOTING ZION

Emerging from Obscurity3
A Girl in Love...4
Accommodating Tourists7
Pretty-face Publicity ...8
Dora's Dizzy Life ..11
All Aboard...12
A Desert Panorama ..15
A Fitting Prologue ..16

PART 2:
A WEEK IN THE PARK

Gigantic Grandeur...20
Weeping Rocks ...25
Reaching New Heights28
Suspended Over a Chasm33
Raging River ...34
Great Stone Faces ...39
Canyon Togs ...44
Scrambling on the Rocks.................................51
Hide and Seek ..57
Meal Time ...58
Campy Capers ...62
Around the Campfire69
Distinguished Visitors73

PART 3:
OPENING THE GATE

Opening Day ...77
Expanding Operations.....................................78
Developing Access ..81
The Flood that Followed.................................82
Biographies:
Anna Gaarden Widtsoe84
Isadora (Dora) Montague...............................85
Elizabeth Mildred Gerrard86
Agness Ellen (Nell) Creer...............................87
Catherine Alice Levering.................................88
Melba Victoria Dunyon...................................89
Notes ..90
About the Authors ..97

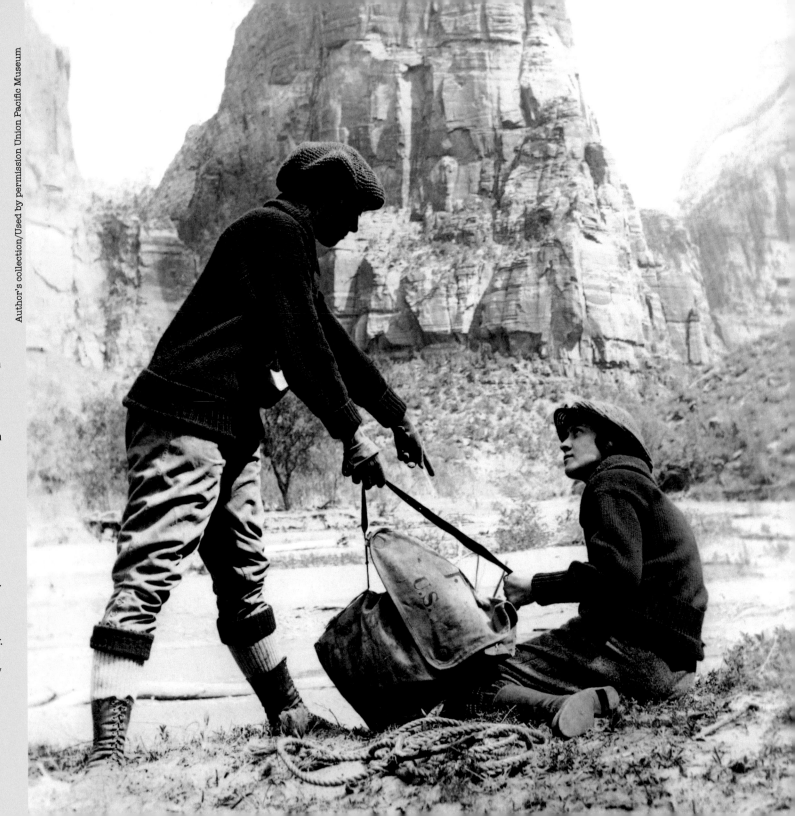

ACKNOWLEDGMENTS

Unlike fiction, the characters of history are real, as are those who retell their stories. To these people we offer our deepest appreciation for the stories they shared with us.

Janet Seegmiller at Southern Utah University took countless hours out of her busy schedule to not only provide us with valuable information surrounding the history of tourist development in and around Cedar City, but also connect us with people who knew this history firsthand.

Dora Montague's personality came alive in the stories told by her daughters. We are indebted to Barbara for sharing her mother's life with us and for images and countless newspaper clippings that documented Dora's diverse exploits. Treasuring her mother's personal history as she has made it possible to know Dora as if she were family of our own. We also thank Elayne for her colorful words describing Dora's journey to Zion. If not for her story, many of Dora's personal journal entries would be lost.

Mary Lou Smoot opened her scrapbooks and photo albums as well, sharing valuable stories about her mother, Mildred Gerrard. She lent us valuable family photos for days, trusting that we would care for them and return them safely. A special thanks is also due to Mary Lou for inviting us into the home where Mildred spent her last days.

Joanne Koplin loved telling us stories about her mother, Anna Widtsoe. From releasing snakes at a school dance, to a run-in with the law for singing and driving, we laugh whenever we think of Anna's pranks.

Anna never told family about her personal journals that now reside at the Utah State Historical Society. We are especially grateful that we could share something with Joanne that she never knew existed.

A special thanks to Louise Parry Thomas who also invited us in to tell us stories and lend us precious family photos of her father Chauncey Parry.

We also extend the same thanks to Melba Dunyon's daughter, Jocelyn, for the history she shared of her mother.

Merle Hobbs Casper deserves recognition for the stories she told about her high school basketball coach, Nell Creer. Without this connection, provided by her grandson Alan Barnett, we would know little about Nell's days as a teacher.

Our families and friends have been tremendously helpful and patient. To them we are grateful for enduring every conversation that seemed to lead to a story about girls in Zion. We cannot exclude our children who have fallen victim to the greatest degree of disruption as we dragged them from one place to another in search of this history. There isn't must to do in the railroad ghost town of Lund, Utah, but the children still endured it with interest.

To Anna, Dora, Mildred, Nell, Melba,
and Catherine, whom we've come
to know, though we never met.

Left, A reluctant Mildred
Gerrard (seated) receives
instructions relevant to
the backpack from an
insistent Anna Widtsoe.

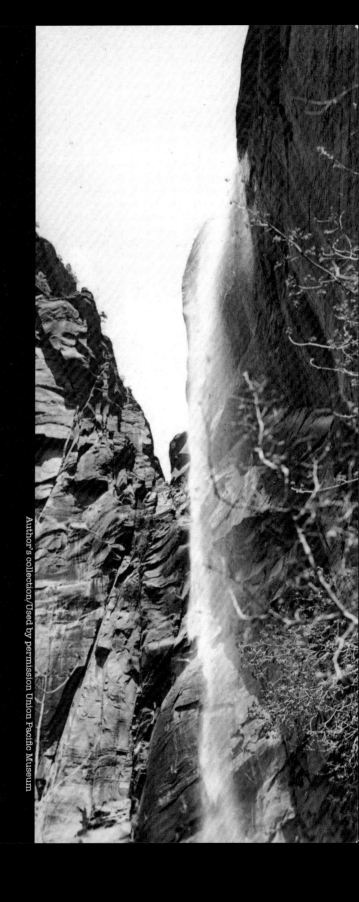

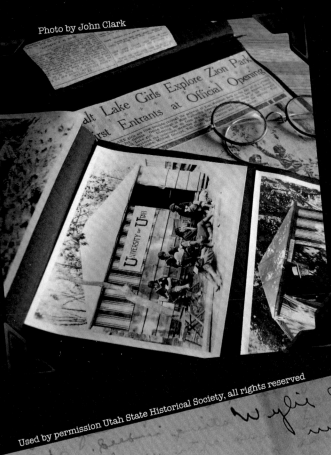

Salt Lake Girls Explore Zion Park

First Entrants at Official Opening

UNIVERSITY OF UTAH

Left, the scrapbooks that were found on eBay. Below, Anna Widtsoe wrote this letter while in Zion. Right, letter to Dora Montague from photographer Eyre Powell accompanied photos like those found in the scrapbooks.

HOTEL UTAH
"THE HOTEL BEAUTIFUL"
GEO. O. RELF.
MANAGER

SALT LAKE CITY

My Dear Miss Montague;—

I inclose a couple of your pictures thinking you might like them.

They were just what I wanted. You look seriously on the job of painting cliff dwellings don't you?

Truly

Eyre Powell

Wylie Camp - Little Zion Canyon
may 8 - 16, 1920

My Dear _____

I am having the most wonderful, glorious time. I am a wee (?) member of it most longlived happy crew. Six girls, our chaperone, five fellows make up the party. The object is to advertise the canyon - and we have our pictures taken in amongst the rocks etc. so as - to accentuate the beauty of the canyon in the pictures. mr. Eyre Powell (Press agent for Union Pacific) is at the head of the party and business manager. Fred Esplin is his keeper. Chauncey Cooper, _____ Bennion are the fellows along. _____ Dragon, mildred Gerrard, wee crier, _____ _____ (Los angeles), mrs. _____ _____. Together

PREFACE

I became the curator of my own museum when I was less than 10 years old. My exhibit consisted of a wooden Ford Model T coil, a 1948 Utah license plate, and a Clover Club potato chip can that my parents brought a tree home in. While other kids in the neighborhood set up lemonade stands, I spread the artifacts out on the front porch of my home. I attempted to collect a nickel per visit. Only my best friend patronized the display, but he refused to pay the required entrance fee.

Photo by Don Clark
Clark family in Zion, 1977.

I have been fascinated with history for as long as I can remember. As a child, I collected every old thing my patient parents let me drag home. I even tried to add an old Model T that I spotted sitting at a service station in Ephraim, Utah, to my collection. My grandma took me into the station where a polite attendant wrote the price on a scrap of paper and told me to give it to my dad. Of course, my father wasn't really in the market for a car that didn't run. Grandma said it would just sit out in a field and get shot full of holes. Somehow that seemed logical to my 10-year-old mind.

I still have the artifacts from my first mu-seum, including the old wood coil that I recently used to replace a faulty part in my restored 1927 Ford Model T.

I am now dragging home whatever my patient wife, Melissa, will allow, but she is no stranger to the love of history. She has a degree in "classics" (the study of Greek and Roman civilizations). Searching for lost treasures compels both my wife and me to drag our children to countless antique shops, network with collectors, dig through archives, and hang out on Internet auction sites to find interesting historical objects.

On a hot July day in 2008, Melissa was looking at old scrapbooks on eBay when she ran across one from an expedition to Zion National Park. A photo of an artist painting in the canyon labeled "Fairbanks" caught her attention.

Only a few images were posted on the auction, but there was enough information to make them very compelling. Melissa found a second auction that contained a similar album. She discovered that the two went together. We bid on them aggressively, winning them both for $131.66.

When they were delivered to our home on August 4, Melissa couldn't wait for me to get home to see them, so she called me at work to describe them over the phone. The covers of the two albums were black and unadorned with the exception of the word "photographs" embossed on only one. The black paper pages inside, however, contained more than 100 images, pasted two per page with captions written on the back of each. There were also several newspaper clippings from Salt Lake City, Los Angeles, Chicago, and Pittsburgh.

I have been a student of Zion's history for some time now. I enjoy reading about early tourism because I have been a frequent visitor to the park since I was very young. Despite what I knew about Zion, however, I had never heard the story that came to life in these scrapbooks.

I am thoroughly convinced that the greatest motivation driving explorers, archeologists and historians to search for the past is the thrill that comes at the moment they discover something that has been lost for a very long time. It is the moment I hold something old in my hands that history is most real. I find that moment to be the best form of time travel yet discovered. As Melissa and I peered into the pages of the two old scrapbooks, we knew we had made a great discovery.

We decided right away that this forgotten story must be retold. We went to work searching for more information about the six young girls who, according to the news clippings of the time, were Zion National Park's first official tourists.

We tracked down several of the girls' families, who told us their stories and provided us with more news clippings, portraits, and details about their mother's lives.

Newspaper archives turned up additional stories and online resources contained interesting facts, but the greatest addition to the story came when we found Anna Widtsoe's personal journal. Anna started a letter to a friend that she never finished. The five-page note was tucked between the pages of her journal, which now resides in the Widtsoe Family Papers collection at the Utah State Historical Society. Details not covered in the formal reports of newsprint told of a "most congenial happy crew" full of fun and mischief. The letter containing the dateline "Wylie camp—little Zion Canyon" was the only entry in her journal about the trip, but every word was like finding a golden nugget.

In late August, we headed for Zion with copies of the photos in hand to search for locations explored by the girls. Some of the places they penetrated in 1920 are no longer accessible to the public, but we still discovered many of the trails they trod. Finding the location of the entrance gate was harder than expected. But as we walked the road in, the cliffs lined up to reveal right where the girls stood on Zion's opening day.

Many of the newspaper clippings pasted in the scrapbooks and published in the *Los Angeles Times* were about Catherine Levering, leading us to believe that these books originally belonged to her. The images and news clippings, carefully preserved by the youngest of the six girls, are the greatest asset to the preservation of this story.

The fact that there is still more to learn about the six young female explorers will keep us searching. Since finding this historic treasure on an Internet auction site, the story of Zion National Park's "first official tourists" has continued to unfold in a series of great revelations, each as thrilling as the first. This book is more of a journey than a destination that I hope you will enjoy as much as my wife and I have. There will always be another great discovery to be made, and it may be right around the next corner.

— JOHN CLARK

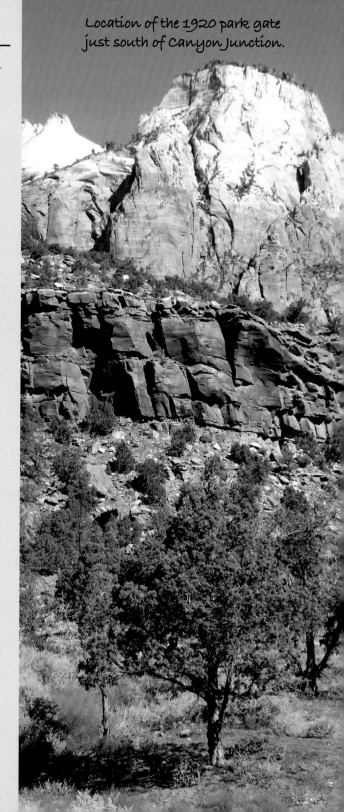
Location of the 1920 park gate just south of Canyon Junction.

Salt Lake Girls Explore Zion Park First Entrants at Official Opening

Salt Lake Herald
-May 18, 1920

Salt Lakers Will Explore New National Beauty Spot

Salt Lake Tribune
-May 9, 1920

Los Angeles Sunday Times.

Zion National Park Now Open to Public

-July 25, 1920

GIRL STUDENTS ENTER ZION NATIONAL PARK.

RUGGED UTAH SCENERY IS OPENED THIS WEEK AS PART OF DOMAIN.

[EXCLUSIVE DISPATCH]
ZION NATIONAL PARK (Uta.
May 17.—An exploring party,
tirely feminine in personnel, is h
at the formal opening of Zion Na
tional

Salt Lake Herald
-May 23, 1920

Zion Beckons to Vacationists Park Open Without Ceremony

The Pittsburg Leader
-May 28, 1920

UNIVERSITY OF UTAH GIRLS IN ZION NATIONAL PARK
Miss Catherine Levering, of Los Angeles, Cal.; Miss Ann Widtsoe, daughter of President Widtsoe, of the University of Utah; Miss Nell Creer, Miss Mildred Gerrard, Mrs. A. V. Peterson, Miss Melba Dunyon and Miss Dora Montague are the girls in the picture, reading from left to right.

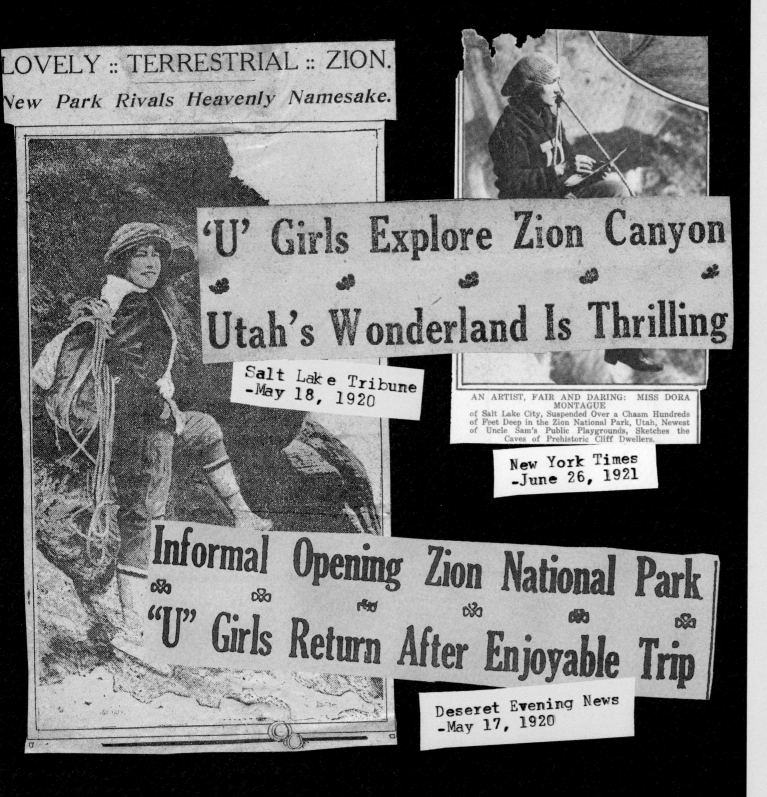

LOVELY :: TERRESTRIAL :: ZION.

New Park Rivals Heavenly Namesake.

'U' Girls Explore Zion Canyon
Utah's Wonderland Is Thrilling

Salt Lake Tribune
-May 18, 1920

AN ARTIST, FAIR AND DARING: MISS DORA
MONTAGUE
of Salt Lake City, Suspended Over a Chasm Hundreds
of Feet Deep in the Zion National Park, Utah, Newest
of Uncle Sam's Public Playgrounds, Sketches the
Caves of Prehistoric Cliff Dwellers.

New York Times
-June 26, 1921

Informal Opening Zion National Park
"U" Girls Return After Enjoyable Trip

Deseret Evening News
-May 17, 1920

INTRODUCTION

The spectacular grandeur of Zion Canyon was formally recognized on July 31, 1909, when it was set aside as a national monument. Then called Mukuntuweap, Zion gained national exposure as one of America's finest scenic playgrounds. In the years that followed, Americans became increasingly mobile as railroads expanded their reach and automobiles made individual mobility available to the masses. Transportation industries, and communities that lay along their routes, could see potential in selling the natural wonders of southern Utah to travelers who would utilize their services to see Zion.

By 1917, tourist services and roads leading into the canyon were improved. The Los Angeles and Salt Lake Railroad, nicknamed the Salt Lake Route, contracted with an automobile stage to transport passengers from the railroad station at Lund, Utah, to Zion. They also arranged for camping facilities in the canyon to accommodate travelers. The railroad took a particular interest in promoting Zion as a tourist destination, producing brochures, providing news stories, and arranging publicity stunts to appeal to the traveling public.

In the spring of 1920, six young ladies were selected to launch the tourist epoch initiated by the railroad. Five of them were University of Utah students who traveled to Lund from Salt Lake City and the other came from Los Angeles via the Salt Lake Route. Using the established auto stage, they were taken to the canyon where they spent the week as models for a railroad publicity campaign. They explored hill and vale, climbing over rocks and fording streams while railroad press agents captured their adventure on film.

When Zion was named as a national park on November 19, 1919, the big wooden gate that stretched across the road into the park was closed to the public for the season. On the morning of May 15, 1920, as their trip drew to a close, the young explorers unlatched the secure entrance and without elaborate ceremony opened Zion's first tourist season as a national park. Though they were not the first travelers to enter Zion's gates, this event gave the girls claim to the title of Zion National Park's first official tourists, a claim that for publicity was broadcast in newspapers around the world.

New York, Boston, Chicago, Los Angeles, and even London published the news that America's newest national park had been opened by the six young ladies.

This is their story in pictures. Taken mostly from some of their personal scrapbooks, this book follows their journey as it begins and leads to Zion National Park's opening day.

PART I:

PROMOTING
ZION

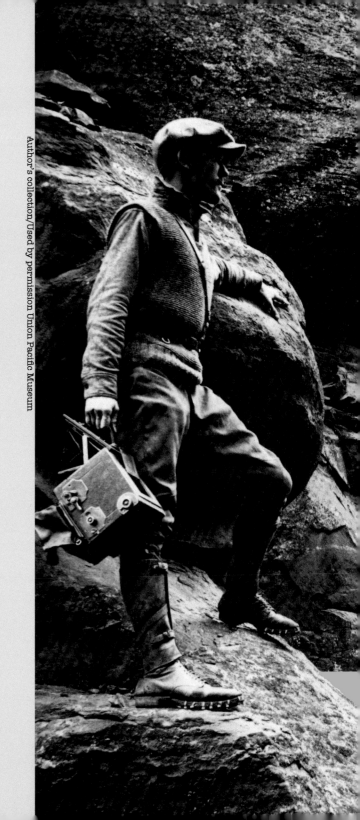

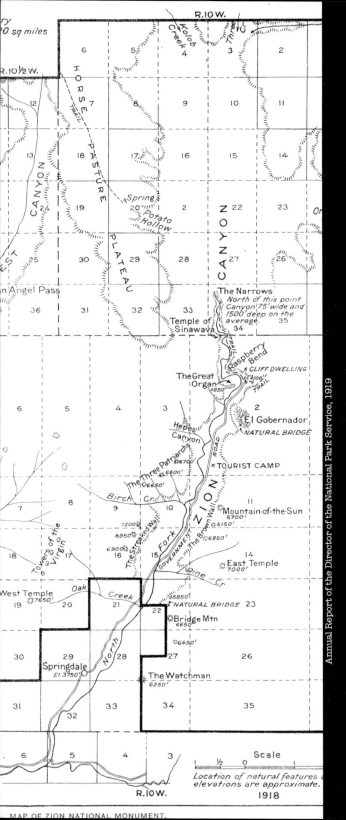

Annual Report of the Director of the National Park Service, 1919

MAP OF ZION NATIONAL MONUMENT.

Below, Frederick S. Dellenbaugh exhibited paintings of Zion Canyon, including this one, *Zion Canyon*, at the St. Louis World's Fair in 1904.

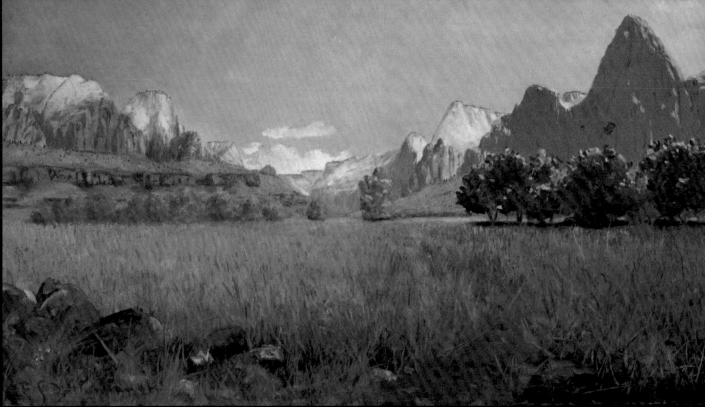

Frederick S. Dellenbaugh, *Zion Canyon*, 1903. Oil on canvas, 15 x 28 in. Courtesy of National Park Service, ZION 38105, Zion National Park Museum Collection

Left, 1918 map of Zion National Monument.

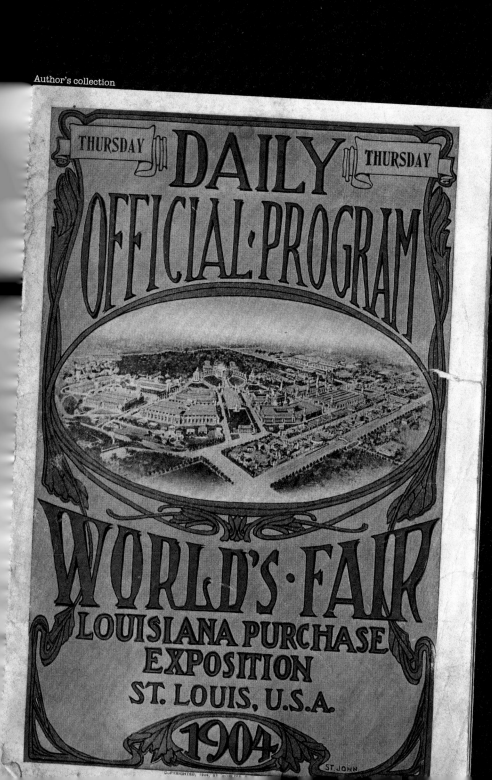

Men of Affairs in the
State of Utah, 1914

Above, Wesley E.
King. King and his
wife, Wilhelmina, were
among Zion's first
tourists. They traveled
by train and buggy to
the canyon in 1911.

EMERGING FROM OBSCURITY

In the summer of 1903, explorer and artist Frederick S. Dellenbaugh wandered into Zion Canyon to paint its towering cliffs. The following year his beautiful art was exhibited at the World's Fair in St. Louis, Missouri. He also wrote an article that appeared in *Scribners' Magazine* in January 1904. "Never before has such a naked mountain of rock entered our minds," Dellenbaugh pondered. "Without a shred of disguise its transcendent form rises pre-eminent. There is almost nothing to compare to it."[1]

The paintings at the fair created a great deal of excitement. Many spectators could hardly believe that such a place existed. David Hirschi, a young man from Rockville, Utah, who was at the St. Louis World's Fair, informed the skeptics that Zion Canyon was indeed real.

Bringing national attention to the canyon contributed to Zion's formal recognition as a national monument on July 31, 1909. Originally christened Mukuntuweap, the newly recognized scenic wonderland was still virtually unknown to the world.

Among the first tourists to make the long trip just to see the canyon was Wesley E. King, a prominent attorney from Salt Lake City. In 1911, he and his wife, Wilhelmina, took the train to Marysvale, Utah, where they obtained a horse and buggy to take them the remaining distance. "We crossed the divide...and began our descent into and upon one of the most wonderful scenic portions of America," King later called it "a territory that will some day attract the attention of the world and one which sightseers will travel from the four points of the compass to view."[2]

At first, only wagons and horses could penetrate the interior of the canyon. The first automobile to venture in wouldn't come until around 1914. Local enthusiasts could see that a good road would be required if more people were to see Mukuntuweap's beauty. They petitioned the Utah state government for improvements that resulted in the canyon's first improved road by the summer of 1917.[3]

Officially renamed Zion National Monument on March 18, 1918, the canyon received enthusiastic publicity from Salt Lake and southern Utah commercial interests. This, combined with greater access, led an increasing number of tourists to Zion's gates. By the end of the 1919 season, 1,814 people had entered Zion Canyon that year alone, according to Walter Ruesch, park custodian.[4]

A GIRL IN LOVE

At the age of 20, young Anna Widtsoe was the typical girl in love. The object of her affection was Chauncey Parry. "He's the one, you've met the right one at last," Anna wrote in her diary following their first date. "I wonder can that be so. From all I know and feel now I hope so."[1]

Anna was the daughter of John A. Widtsoe, who later became an apostle of The Church of Jesus Christ of Latter-day Saints. Anna faithfully followed the convictions of her father and mother, Leah, despite her departure from traditional social boundaries. For example, she not only drove automobiles, but repaired them. She was a gregarious girl who spoke her mind and certainly liked to date. "I dare not tell mother of my newly started romance," Anna said of her feelings for Chauncey, "for she wouldn't understand and would most certainly have me out."[2]

Chauncey, who had recently returned from serving in World War I, spent some time off and on with his parents in Salt Lake City. It was on June 30, 1919, that he asked Anna on a date to Lagoon, an amusement park north of Salt Lake. Following their date, Anna hoped that Chauncey would call for the Fourth of July, but he was apparently out of town. Knowing that Chauncey was back in town on July 7, Anna waited patiently for him to call. "He came and he called and he came up and we went out,"[3] Anna wrote excitedly in her diary. "Heaven grant that I may be worthy of such a man's love as Chance." Anna wrote near sonnets to Chance for nearly a month, hoping and dreaming of what the future might bring.

Unfortunately for Anna, Chauncey Parry was an ambitious man, often away on business. He spent little time in any one place after his return from the war.

Perhaps de-energized by the distance, Anna's feelings for Chauncey quickly subsided. "I wasn't keen about him," Anna wrote three weeks after their first date. "He sure is a dandy swell fellow but as a friend only do I like him. We parted friends."[4]

In the spirit of young love, Anna soon found another object of affection. True to her words, however, she remained friends with Chauncey, a relationship that would reap rewards in the year to come.

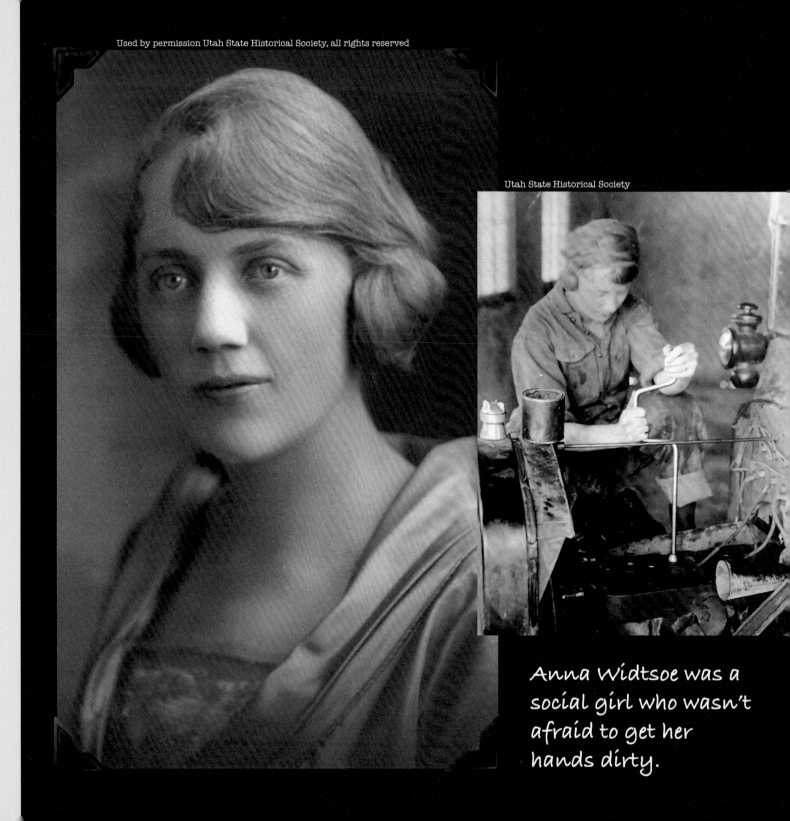

Utah State Historical Society

Anna Widtsoe was a social girl who wasn't afraid to get her hands dirty.

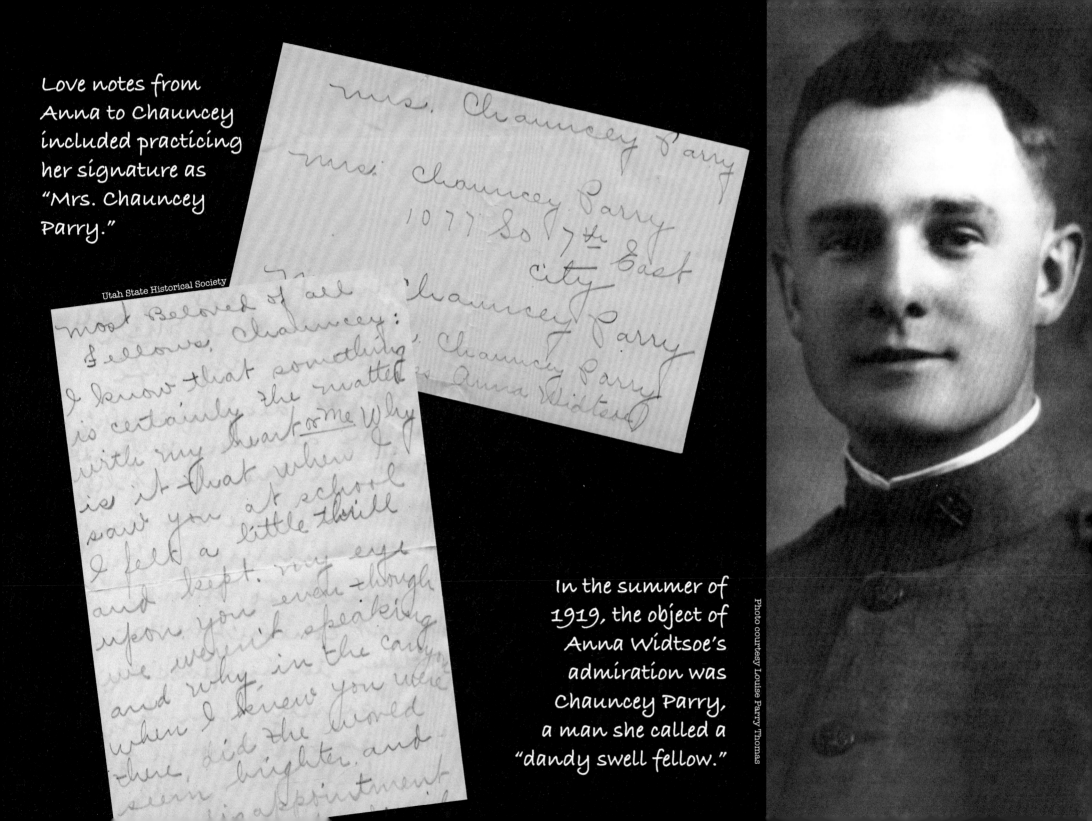

Love notes from Anna to Chauncey included practicing her signature as "Mrs. Chauncey Parry."

In the summer of 1919, the object of Anna Widtsoe's admiration was Chauncey Parry, a man she called a "dandy swell fellow."

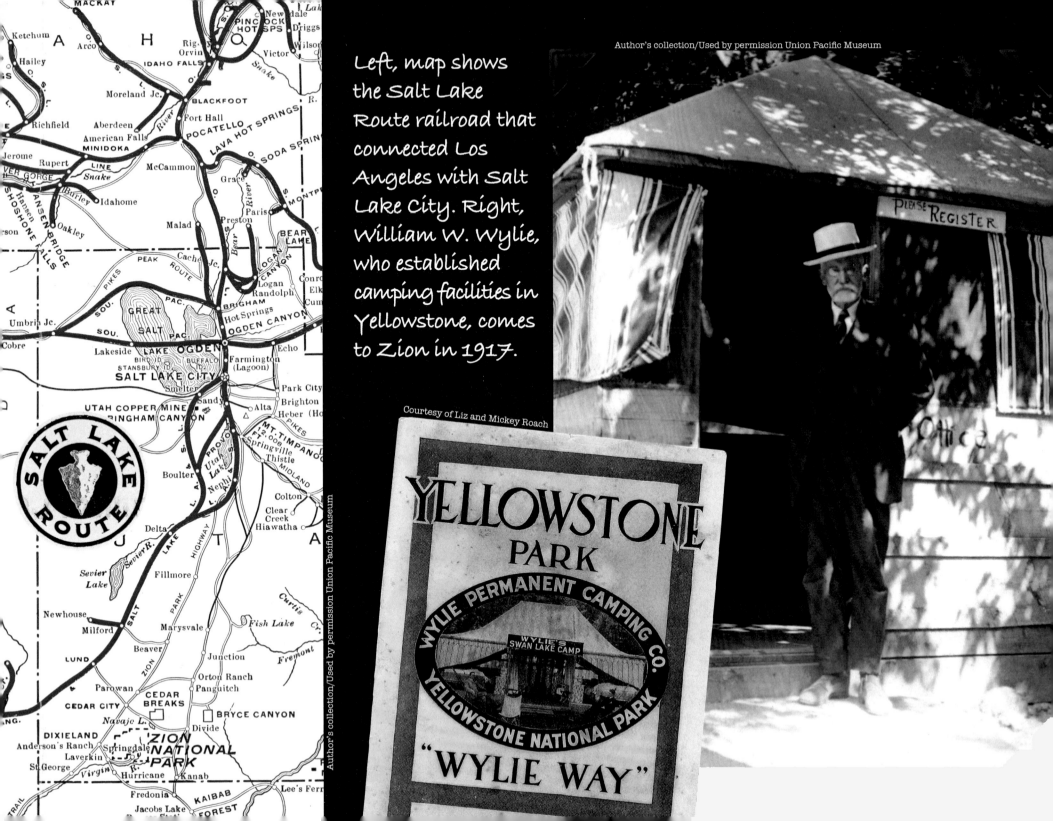

Left, map shows the Salt Lake Route railroad that connected Los Angeles with Salt Lake City. Right, William W. Wylie, who established camping facilities in Yellowstone, comes to Zion in 1917.

PLEASE REGISTER

Office

SALT LAKE ROUTE

YELLOWSTONE PARK

WYLIE PERMANENT CAMPING CO.

WYLIE'S SWAN LAKE CAMP

YELLOWSTONE NATIONAL PARK

"WYLIE WAY"

Special Collections Gerald R. Sherratt Library Southern Utah University

Above, Chauncey Parry (right) and his brother, Gronway, operated an automobile stage from Lund, Utah, to Zion Canyon. Left, the United States Railroad administration created this brochure to promote tourism.

Author's collection

ACCOMMODATING TOURISTS

Chauncey Parry's brother, Gronway, moved to Cedar City in 1915 after graduating from college. He first worked as the Iron County agricultural agent but soon found himself involved in a variety of occupations, including starting a steam laundry and automobile sales. In 1916 he enticed Chauncey away from the University of Utah to help manage the Cedars Hotel and operate an automobile stage line from the railroad station in Lund to St. George, Utah.[1] The Parry brothers' experience with an automobile stage would soon work to their advantage.

The Salt Lake Route, which was owned in part by the Union Pacific Railroad, ran from Salt Lake City to Los Angeles.[2] Passing through the heart of the scenic West, the railroad recognized early on that promoting the scenery in southern Utah would be good for business.

In October 1913, Douglas White, industrial agent for the Salt Lake Route, accompanied Utah Governor William Spry to Zion Canyon to explore its tourism potential. Spry and White were joined by a group of businessmen from the Wylie Permanent Camping Company, which operated in Yellowstone Park. Calling it the "eighth wonder of the world," Douglas White praised Zion, convinced that accommodations must be made for railroad tourists who wanted to see the canyon.[3]

In January 1917, railroad officials announced that an automobile stage would be established between Lund, on the railroad, and Zion. They also announced that camping facilities would be provided in the canyon.[4]

The following month, Gronway picked up William W. Wylie and railroad officials in Lund, then transported them to Zion to make final arrangements for tourist services in the canyon. Wylie, who had established the camping facilities in Yellowstone, said, "I am astonished at the magnificence and beauty of the Zion Canyon.... It is immense, it is delightful, it is so restful too."[5]

Gronway and Chauncey Parry were awarded the transportation contract, with Wylie managing the camping accommodations. In April 1917, they incorporated as the "National Park Transportation and Camping Company." World War I would take the Parry brothers away from the business during the 1918 season. Chauncey, however, returned home early in 1919, anxious to go back to work. He wasted little time re-establishing the stage service once proper arrangements could be made.[6]

Opening Zion — 7

PRETTY-FACE PUBLICITY

The gate to Utah's first national park was closed for the season on November 19, 1919, when Zion was formally elevated from monument to national park status. Inspired by the new designation, the Union Pacific Railroad began planning to promote Zion when it reopened for tourists in the spring of 1920.

Eyre Powell, press representative for the Union Pacific, wrote to railroad official Dan Spencer in Salt Lake City, on January 6, 1920, suggesting that they advertise their presence in the new national park. One idea involved hosting a theatrical pageant.[1] Powell visited Salt Lake City later that month to stimulate interest in the Utah wonderland. "People on the coast are beginning to talk of Utah as a place to spend their summer's vacation," the Los Angeles native told the *Salt Lake Tribune*. "They say they are tired of the seashore and want to seek rest and seclusion in the mountains."[2]

Returning to Salt Lake City on April 14, 1920, Powell and businessmen at Salt Lake's Commercial Club began planning a pilgrimage to the park for May 15, the day Zion would open for the season.[3] At first it was thought that the arrangements would include a large automobile expedition to the park. However, a plan emerged that was a better test of the railroad's services. A group of tourists would be invited to take the train from Salt Lake City to Lund and on to Zion by way of the automobile stage.

On April 17, while still in the city, Eyre Powell joined Chauncey Parry to select the sightseers, and who better to sell beautiful scenery than a pretty young face. Having been a student himself for at least two years, Chauncey used his connections with the University of Utah to find the perfect models for the excursion. "Went down town in [the] afternoon to meet with Chance Parry and some Chi O's to discuss proposition for a trip," Anna Widtsoe wrote in her diary. "The purpose is for advertising and expenses free. Oodles of fun free for just the privilege of taking our pictures."[4] Chauncey, of course, knew Anna and her father, who was the president of the university. John Widtsoe was most likely involved in selecting which girls from the Chi Omega sorority would meet with Chauncey and Eyre about the trip.

Anna decided to go, as did three other members of the sorority. Melba Dunyon, a skilled musician, Marjorie Burrows, a girl with a flair for acting, and Mildred Gerrard, who wasn't considered the adventurous type, also agreed to make the trip to southern Utah.

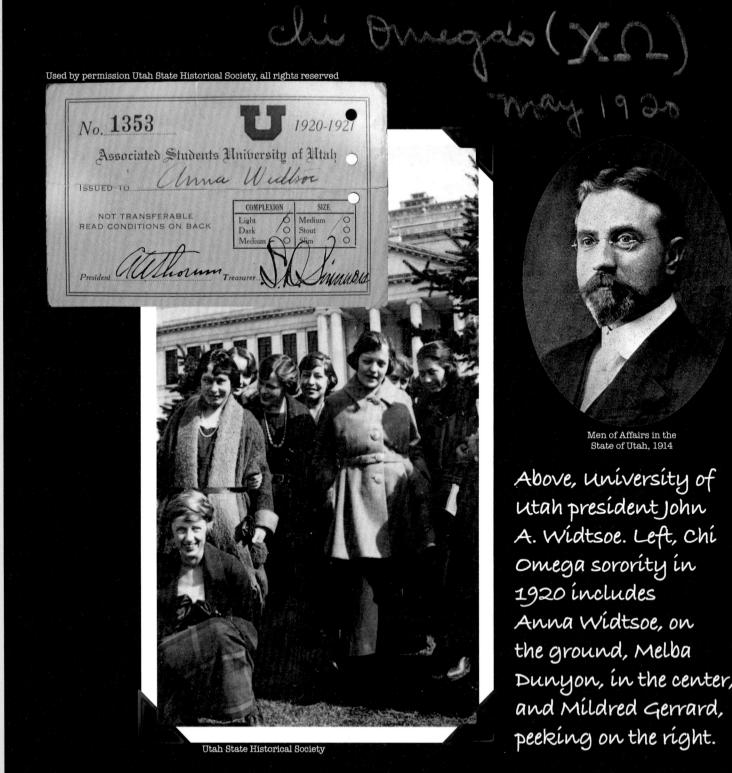

chi Omega's (XΩ) may 1920

No. 1353 U 1920-1921

Associated Students University of Utah

ISSUED TO *Anna Widtsoe*

NOT TRANSFERABLE
READ CONDITIONS ON BACK

COMPLEXION		SIZE	
Light	○	Medium	○
Dark	○	Stout	○
Medium	○	Slim	○

President _____ Treasurer _____

Men of Affairs in the
State of Utah, 1914

Utah State Historical Society

Above, University of Utah president John A. Widtsoe. Left, Chi Omega sorority in 1920 includes Anna Widtsoe, on the ground, Melba Dunyon, in the center, and Mildred Gerrard, peeking on the right.

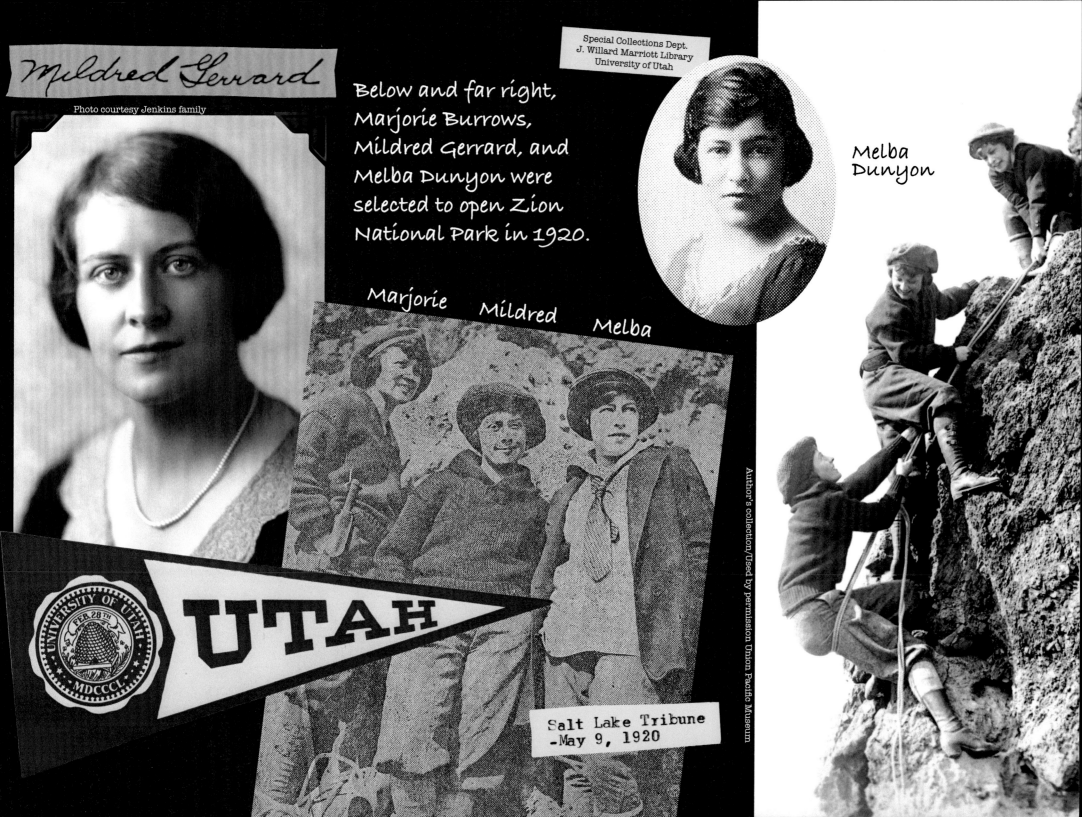

Mildred Gerrard

Below and far right,
Marjorie Burrows,
Mildred Gerrard, and
Melba Dunyon were
selected to open Zion
National Park in 1920.

Melba
Dunyon

Marjorie Mildred Melba

UTAH

UNIVERSITY OF UTAH
FEB. 28TH
MDCCCL

Salt Lake Tribune
-May 9, 1920

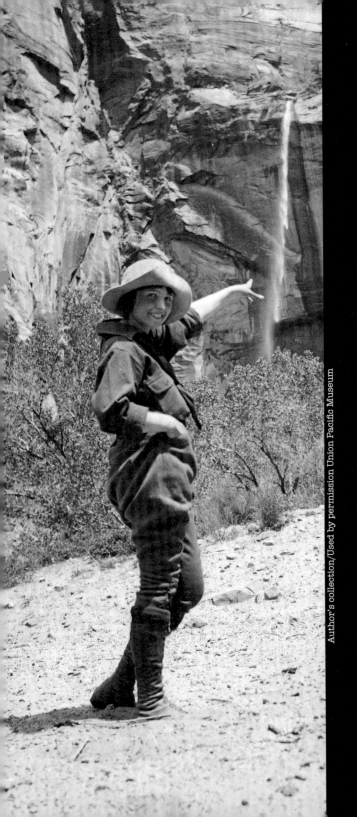

Dora Montague often made headlines as a model for outlandish publicity stunts.

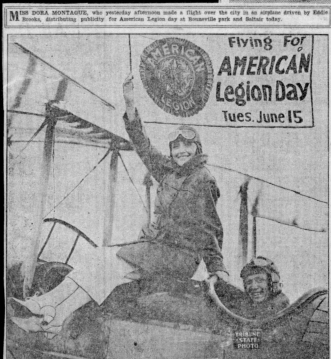

MISS DORA MONTAGUE, who yesterday afternoon made a flight over the city in an airplane driven by Eddie Brooks, distributing publicity for American Legion day at Bonneville park and Saltair today.

Flying For AMERICAN Legion Day
Tues. June 15

Salt Lake Tribune
-June 15, 1920

Salt Lake Herald
-February 11, 1920

Art From a Safe Distance

THE dizzy life of a modern artist is here shown at its dizziest. Miss Dora Montague, University of Utah art student, is not scanning the horizon for help, however. Three miles across the yawning chasm are Utah's most recently uncovered cliff dwellings, and because they are unapproachable by any other means, Miss Montague has chosen the quite unusual method of bringing the mountain to her through the lens of a pair of field glasses. Thus, with glasses in one hand and crayon in the other, Miss Montague is actively doing her ... unrivalled for beauty and distinction any place

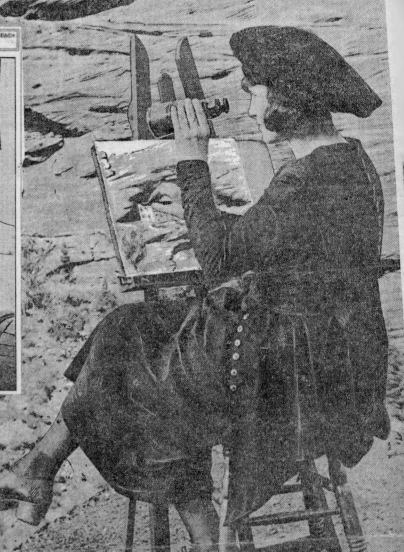

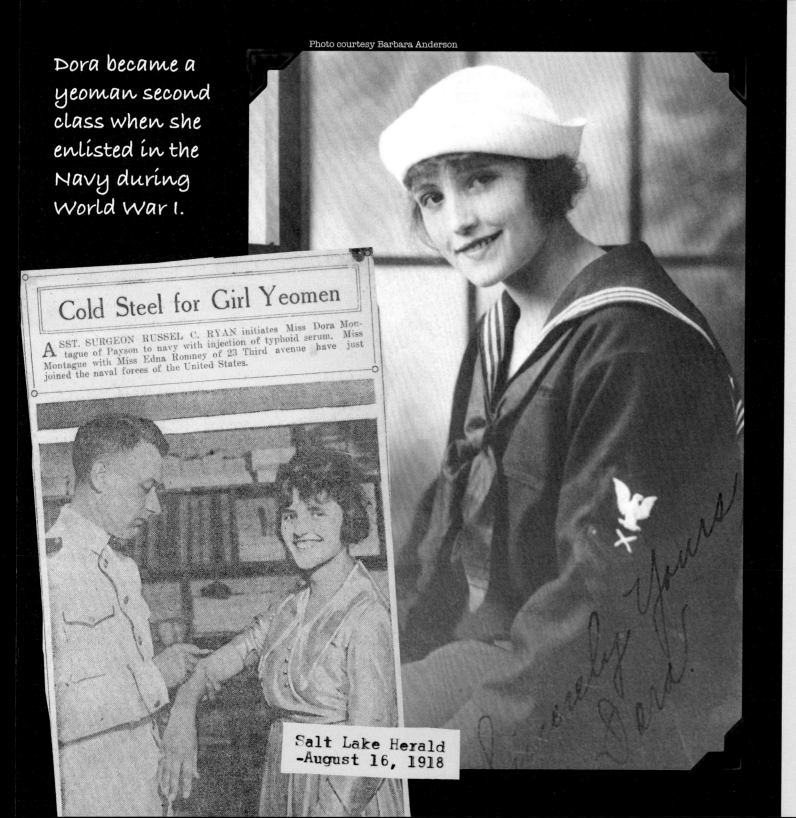

Dora became a yeoman second class when she enlisted in the Navy during World War I.

Cold Steel for Girl Yeomen

ASST. SURGEON RUSSEL C. RYAN initiates Miss Dora Montague of Payson to navy with injection of typhoid serum. Miss Montague with Miss Edna Romney of 23 Third avenue have just joined the naval forces of the United States.

Salt Lake Herald
—August 16, 1918

DORA'S DIZZY LIFE

Dora Montague didn't seem to be frightened by anything. When she was only 17 years old, she sued the Orem Interurban Railway for negligence following an automobile accident with one of their trains. Dora sustained serious injuries as a passenger in the car that was struck. Even at her young age she wasn't afraid to take on the railroad company, and she was awarded $1,090 in damages.[1]

While many young men across the country were signing up to serve in World War I, Dora was one of the few women who enlisted. In the summer of 1918, she joined the Navy, becoming a yeoman second class.

"Going to faint?" the officer administering typhoid serum asked Dora. "A-a-a-er-a-a-No sir," she replied. "The girls kept their resolve not to faint," the *Salt Lake Herald* reported, "though that sudden prick in the arm did make them forget for just the tiniest second that the government refers to them as 'yeomen' and probably expects them to leave feminine foibles behind when they join a man's outfit." Dora served as a clerk in the naval recruiting office in Salt Lake City.[2]

Her taste for adventure made Dora a great model for outlandish publicity stunts that were often splashed across newspaper pages. One of her most memorable stunts involved dropping fliers from the open cockpit of a biplane. The American Legion convinced her to distribute literature from that precarious perch to advertise American Legion Day in Salt Lake. Miss Montague proclaimed her aerial experience to be "something immense."[3]

In February 1920, Dora again appeared in print for painting on the canyon rim of Zion. The University of Utah art student was photographed, most likely by railroad press agent Eyre Powell, in the park before its official opening. "The dizzy life of a modern artist is here shown at its dizziest," the *Salt Lake Herald* reported. "Miss Montague is actively doing her bit to tell the world that Utah has a Zion National Park—unrivaled for beauty and distinction any place on the globe."[4]

Miss Montague received the opportunity to continue broadcasting the beauties of Zion when, in May, her name was added to the list of university girls on their way to open the park to the world. Dora was a perfect choice for a publicity campaign designed to sell the untamed beauty of Zion.

ALL ABOARD

With the trip now organized, Anna Widtsoe, Melba Dunyon, Mildred Gerrard, Dora Montague, and Nell Creer gathered at the train station in Salt Lake City, prepared to embark on their great adventure. At the last minute, Miss Marjorie Burrows had accepted a leading role in the University of Utah school play and could no longer go. Nell Creer, also a member of the Chi Omega sorority, was selected to replace her.

"Saturday evening, May 8, we donned our canyon togs (composed of army pants, golf stockings, rolled just below the knee, high boots, "U" sweaters and caps [tams]) and went to the depot," Anna Widtsoe remembered. "We boarded the train early (the train didn't leave until 11:55 p.m.) and got settled and then came back in the station to see our friends and tell them goodbye."[1]

The five girls were introduced to Mrs. Stella Peterson, wife of railroad agent Alfred Peterson, who had accepted the position of chaperone. "Uncle Dan Spencer told chaperone when she saw the beginnings of a romance to 'nip it in the bud,'" Anna recalled at their meeting. "We used that expression for sundry things and finally called the chaperone the 'nipper.'"[2]

"About eleven-thirty we went aboard for the night," Anna said. "I was low-sick and [had] a most terrible cold. But, I couldn't be bothered by such small matters as colds etc."[3] They slept on lower berths as the train rambled south through the night. "In the morning, after a delicious breakfast at the hotel at Milford [Utah], we again went on the train for a short ride to Lund—our destination." [4]

The party met two others in Lund, Catherine Levering and Fred Coffey, who both came up from Los Angeles. Catherine was a talented musician and dancer who lived in Salt Lake City with her mother and stepfather for eight years before moving to Los Angeles to study in 1919. She had a reputation in California music circles for her talents. The *Los Angeles Evening Herald* said she was "acclaimed by musical critics as one of the most promising artists of the present generation."[5] Catherine was the only girl on her way to Zion who wasn't in college. At 14 years old, she was the youngest girl to join the expedition.

Fred Coffey worked for the Union Pacific Railroad as an assistant to Mr. Eyre Powell, the railroad press agent who was at the head of the party to Zion. At some point, Al Pyper and Marve Bennion also joined the group. Mr. Pyper worked for Chauncey Parry as a driver.[6]

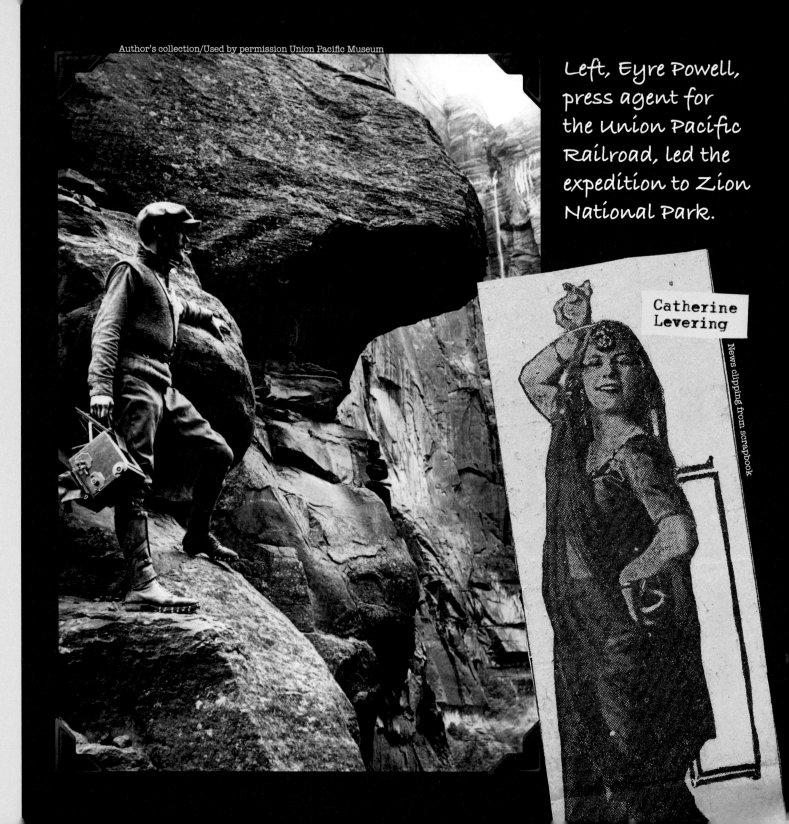

Author's collection/Used by permission Union Pacific Museum

Left, Eyre Powell, press agent for the Union Pacific Railroad, led the expedition to Zion National Park.

Catherine Levering

News clipping from scrapbook

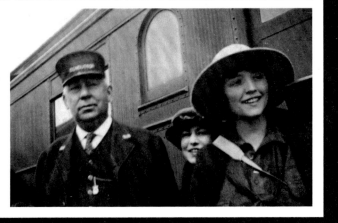

Special Collections Dept.
J. Willard Marriott Library
University of Utah

Nell Creer

Far right, Stella Peterson played the role of chaperone. Below, railroad station in Salt Lake City where the adventure began.

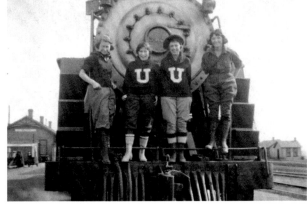

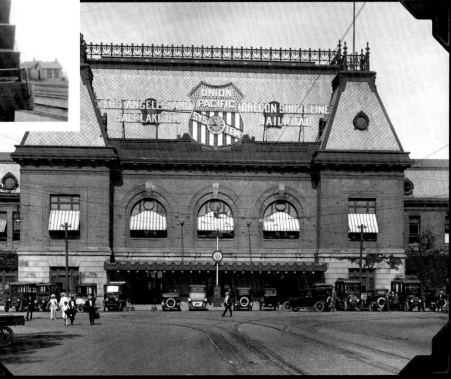

Above top, Melba and Dora pictured with the train conductor. Above, Mildred, Melba, Anna, and Dora pose on train engine in Lund.

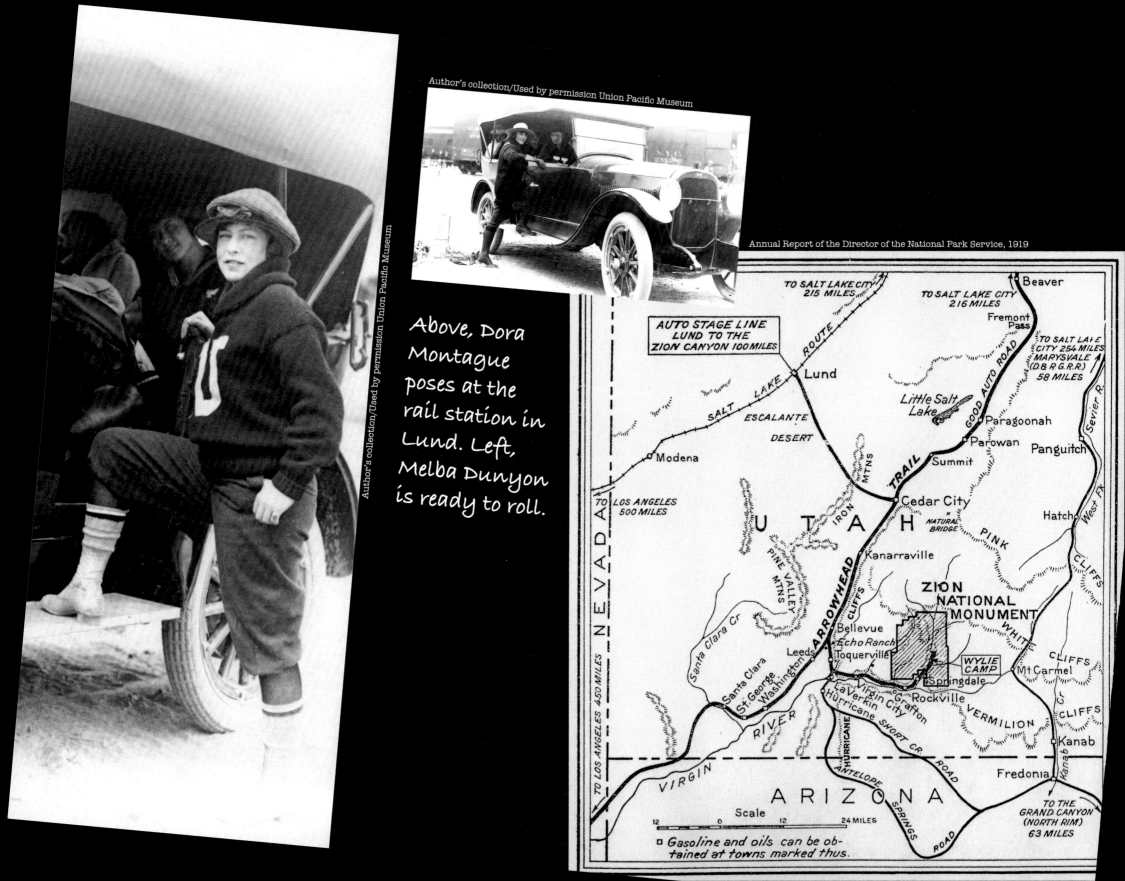

Above, Dora Montague poses at the rail station in Lund. Left, Melba Dunyon is ready to roll.

AUTO STAGE LINE
LUND TO THE
ZION CANYON 100 MILES

TO SALT LAKE CITY 215 MILES

TO SALT LAKE CITY 216 MILES

Beaver

Fremont Pass

TO SALT LAKE CITY 254 MILES MARYSVALE (D & R.G.R.R.) 58 MILES

SALT LAKE ROUTE

Lund

Little Salt Lake

GOOD AUTO ROAD

Paragoonah

ESCALANTE DESERT

Parowan

Panguitch

Modena

IRON MTNS

Summit

TRAIL

PINK

Sevier R.

TO LOS ANGELES 500 MILES

U T A H

Cedar City

NATURAL BRIDGE

Hatch

West Fk.

N E V A D A

PINE VALLEY MTNS

ARROWHEAD

Kanarraville

CLIFFS

ZION NATIONAL MONUMENT

WHITE

CLIFFS

Santa Clara Cr

CLIFFS

Bellevue

Echo Ranch

WYLIE CAMP

Mt Carmel

CLIFFS

TO LOS ANGELES 450 MILES

Santa Clara

Leeds

Toquerville

Springdale

Rockville

VERMILION

St George

Washington

La Verkin

Virgin City

Grafton

Hurricane

CLIFFS

RIVER

Kanab

HURRICANE

SHORT CR.

Kanab Cr.

VIRGIN

ANTELOPE

ROAD

Fredonia

A R I Z O N A

SPRINGS

ROAD

Scale

12 0 12 24 MILES

TO THE GRAND CANYON (NORTH RIM) 63 MILES

□ Gasoline and oils can be obtained at towns marked thus.

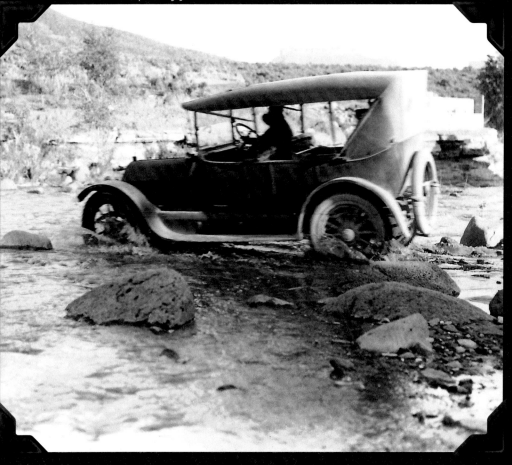

Left, written on the back of this photo: "fording or rather cadillacing." The auto stage on the road to Zion. Below, the girls pose with an unamed man on top of wool bales.

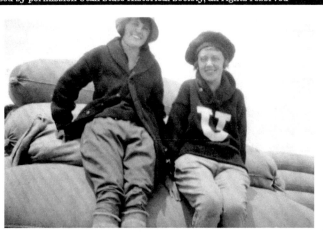

Nell Anna

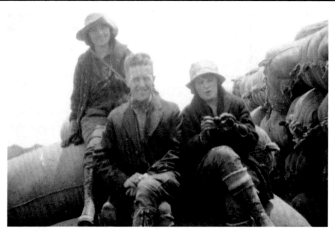

Dora Nell

A DESERT PANORAMA

"'The exploresses' left the railroad at Lund, Utah, en route to Zion Canyon," wrote Eyre Powell for the *New York Tribune*. "There they were met by stages of the new park's transportation system; and with barracks, bags, packs, ropes and other equipment lashed to every available part of the cars were carried through the 'Dixie' country."[1] When the girls arrived in Lund on the morning of May 9, the motor stages managed by Chauncey Parry were already waiting to take them to Zion. The party struck out across the desert shortly after 10 in the morning. "Mr Jim Urie … drove our car," Anna Widtsoe recalled.[2]

"The short stretch of typical American desert between Lund and Cedar is most interesting," the *Salt Lake Tribune* said of the route. "It is not long enough to become at all monotonous and the road with the exception of a mile or so near Lund is good." Furthering their promotional praise, the *Tribune* said, "no human stage manager or human psychologist could have arranged the scenes along the road with such delicate skill, starting with a desert panorama of green sagebrush, yellow sand and blue buttes and graduating as they do, color by color, scene by scene, each greater than the last, in preparation for the final stupendous sight met in entering the great gorge."[3]

Scenery wasn't the only curiosity along the trail. The expedition took a brief break at a sheep camp before completing the drive into Cedar City. "As the road rose over the hills and the desert changed into the high sheep-grazing country to the west of Cedar, a stop was made to watch the 'woolies' being sheared," the *Salt Lake Tribune* wrote.[4] "Very interesting indeed," Anna observed.[5] "Just past the clipping camp, the road topped the rise and the rich ranching country bordering the Arrowhead Trail came into view, with the vermilion cliffs in the background."[6]

"At Cedar, we stopped at the hotel and after washing, we had the best dinner," Anna Widtsoe wrote.[7] For the average tourist, lunch at the hotel in Cedar City would have cost .75¢, or "the usual six bits," as the *Salt Lake Tribune* put it.[8]

"We also sent cards to our friends at home," Anna continued. Always the socialite, Anna remembered that she met some old "Phi Delts" while in Cedar and one of them drove her over to see a friend named Roy Homer.[9]

A FITTING PROLOGUE

Following Anna Widtsoe's social call, the party climbed back into the automobiles for the final stretch. "After lunch [in Cedar City], the Arrowhead Trail is followed for some distance, being left a half mile north of the famous Echo farm," the *Salt Lake Tribune* stated.[1]

The Arrowhead Trail was the name of the main automobile road between Los Angeles and Salt Lake City. It followed the basic route of modern I-15. The Arrowhead name came from a natural formation in the mountains above San Bernardino, California, that resembled an arrowhead. The trail was heavily advertised as a feasible route for automobile tourists who were on their way to Southern California. Side-trip attractions such as Zion added to the appeal of taking the promoted road. Not long after Zion was named a national park in 1919, Salt Lake City advocates changed the name of the road to Zion Park Highway on locally published touring maps. The caravan of university girls followed the advertised trail.

Anna said they stopped in "Lakeville" to rest. She was most likely talking about Echo Farm or Anderson's Ranch, as it was also called. The ranch, near present-day Toquerville, was a convenient stopping place for travelers who were on their way to Zion.

The party was having a good time even though Anna wasn't feeling well. "We were all happy and peppy and had oodles of candy," Anna recalled. "I had a worse cold, but just the same, candy and we are friends."

"The country was beautiful, and the cutest little towns we passed through," Anna Widtsoe also observed.[2] "After the run through a region of green ranches, black lava hills and winding canyons along the line of the great Hurricane fault," the *Salt Lake Tribune* said, "another rise is topped and the first really great panor-ama of an infinite series is seen, with the wonderfully green little valley surrounding Toquerville below and the first multi-colored spires of the Zion region far in the distance."[3]

The *Salt Lake Herald* also raved about the scenery leading to Zion. "From this point on, the trip is a series of stupendous panoramas, each one more colorful and marvelous than the last." The newspaper described the trip from Lund to Zion as "a fitting prologue and a necessary preparation for the greatest spectacle of creation."[4]

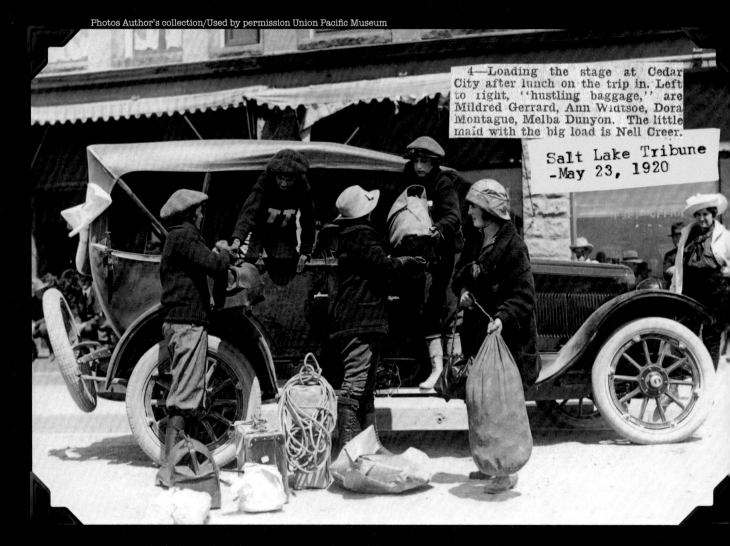

4—Loading the stage at Cedar City after lunch on the trip in. Left to right, "hustling baggage," are Mildred Gerrard, Ann Widtsoe, Dora Montague, Melba Dunyon. The little maid with the big load is Nell Creer.

Salt Lake Tribune —May 23, 1920

Right, Dora and Chauncey enjoying more than just the scenery.

Right, Mildred Gerrard at Andersons Ranch. Below right, Lila Higbee, the "village belle," brings Chauncey Parry a glass of water.

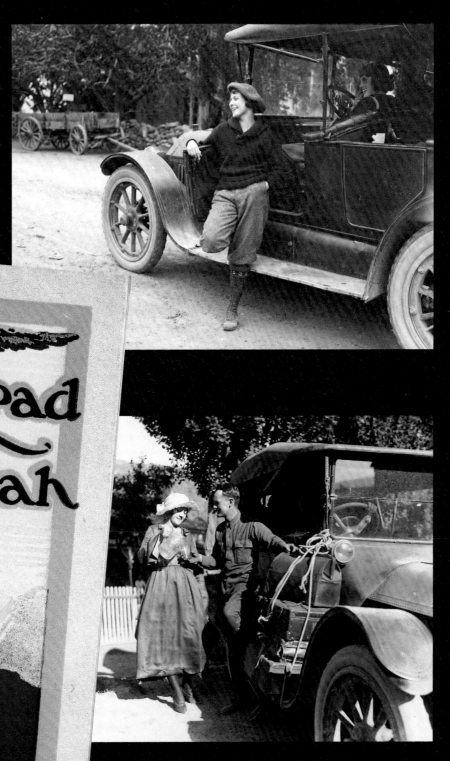

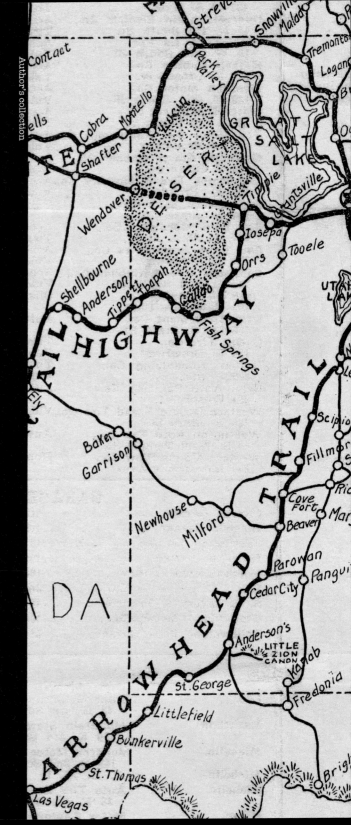

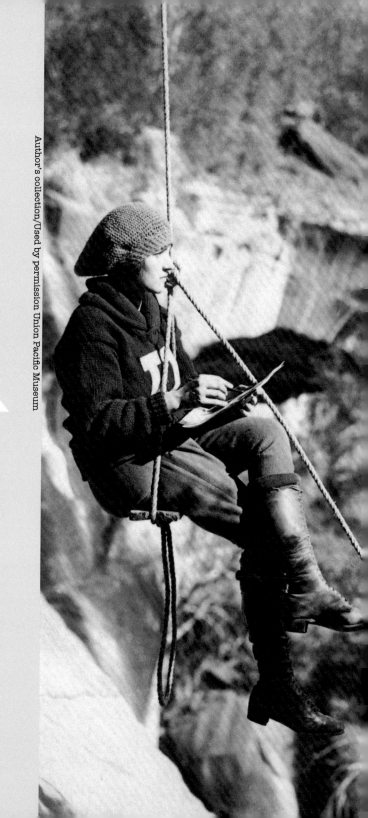

Author's collection/Used by permission Union Pacific Museum

PART 2:

A WEEK IN THE
PARK

GIGANTIC GRANDEUR

"It is a moot question as to the greater thrill—whether one would get it by going there blindfolded and seeing Zion first in one tremendous eyeful, or whether it is gotten [sic] as the traveller ordinarily gets it by degrees in an infinity of kaleidoscopic scenes each greater than the last."[1]

Upon their arrival at the plain, wooden entrance gate to Zion, the lady explorers started their week in the park sightseeing.

"Coming thro' the canyon I was amazed at the glorious country and wonderful scenes," Anna Widtsoe praised. "Words cannot express the gorgeous magnificent country. The 'something mysterious' that shrouds the mountains lends enchantment. It was evening and a blue haze hung near and on the mountains."[2]

Dora Montague recorded her impressions of the park by saying, "Zion Park is a beautiful world of its own. It has its own wonderfully constructed temples and castles; its own altars and crowned kings; its own patriarchs and Angel's Landing. It is a good world, though, for when one looks upon the gigantic grandeur of it all, it makes one wonder if anything vile or criminal could ever happen in its surroundings. One can think only beautiful thoughts amid such splendor."[3]

They spent the better part of the afternoon stopping to gaze at the towering cliffs, while railroad press photographers snapped the first images of the girls in Zion.

"On the first trip in, the exploring expedition of university maids arrived at Camp Wylie at 6:30 in the afternoon," the *Salt Lake Tribune* reported, "being a little late because of many stops made to photograph interesting places. On a regular run with fewer delays, the Parry stages arrive earlier."[4]

"Arriving at camp," Anna said, "we got our cabins assigned and then had a lovely dinner, such as only the Wylies can prepare."[5] Three cabins were set aside for the group. Mr. Powell and Mr. Coffey were in number six, while number seven was assigned to Mrs. Peterson, Catherine Levering, Nell Creer, and Anna Widtsoe, and number eight was reserved for Melba Dunyon, Mildred Gerrard, and Dora Montague.

According to Miss Widtsoe, the playful group was full of shenanigans, with the exception of their first couple of nights in the park. "No pranks were played and a very tired crew went right to sleep," she said.[6]

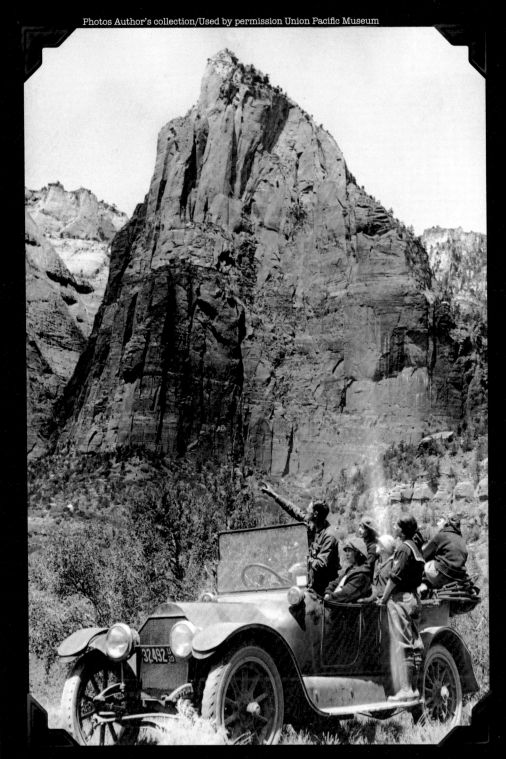

Left, upon entering Zion National Park, the girls spent the better part of the afternoon sightseeing. Opposite, right, Chauncey Parry and Mrs. Stella Peterson. Far right, "Here is one of the views the windshield of the car frames after passing through the national park gates. Two of the Three Patriarchs are shown in the background. These in the foreground—not patriarchs—are Chauncey G. Parry and Miss Catherine Levering."
— Salt Lake Tribune May 23, 1923

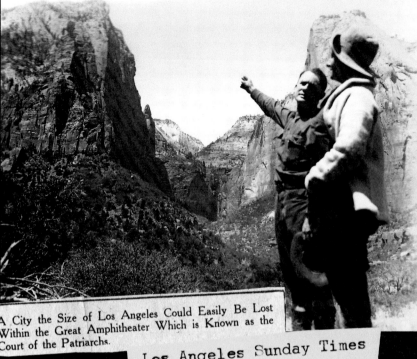

A City the Size of Los Angeles Could Easily Be Lost Within the Great Amphitheater Which is Known as the Court of the Patriarchs.

Los Angeles Sunday Times
-July 25, 1920

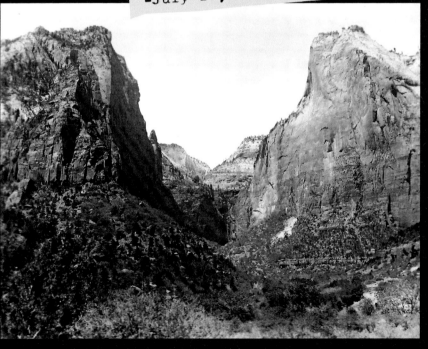

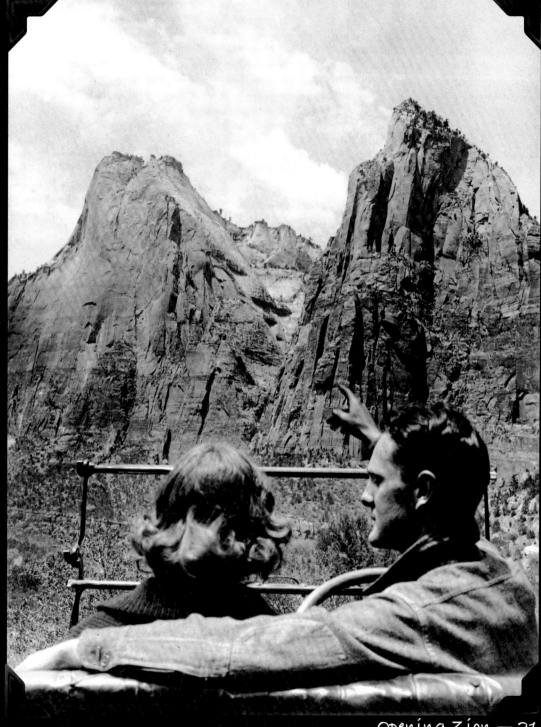

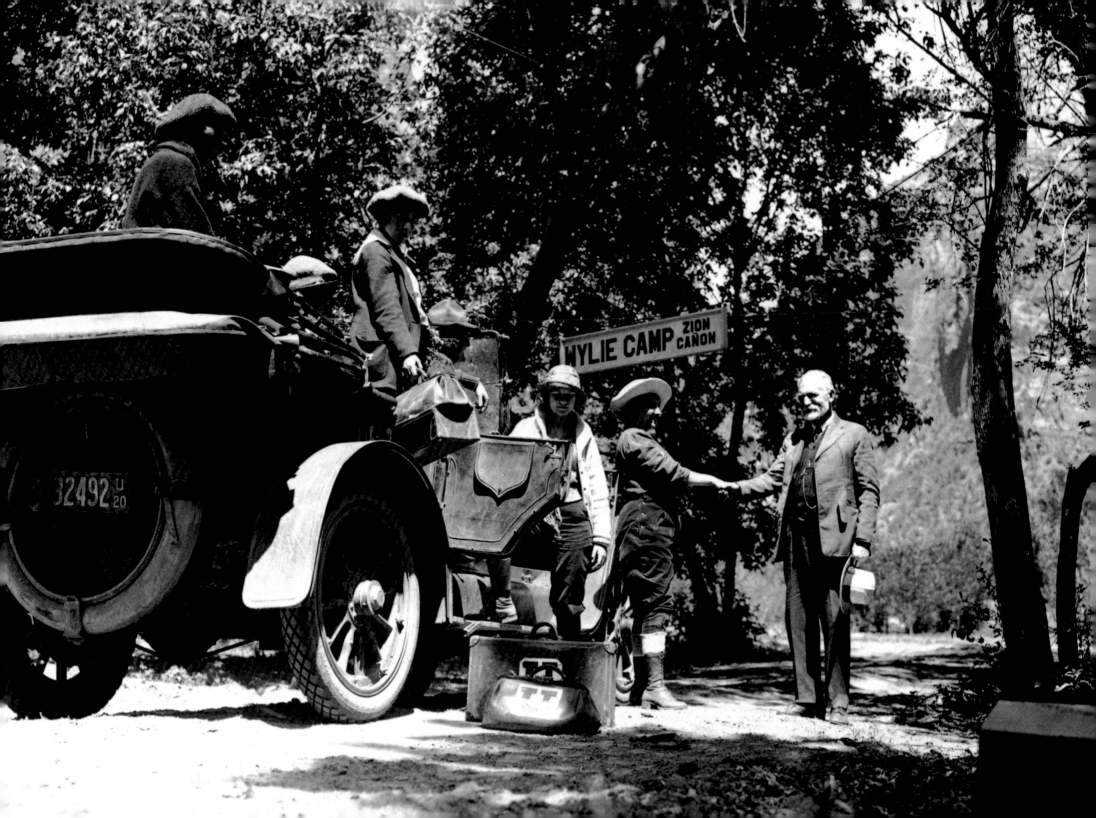

2—The arrival at Camp Wylie. W. W. Wylie, famous national park man, meets the motor cars and is seen greeting Mrs. A. V. Peterson.

PLEASE REGISTER

Catherine Levering

Above and left, Catherine Levering signs the Wylie Camp register as W. W. Wylie watches.

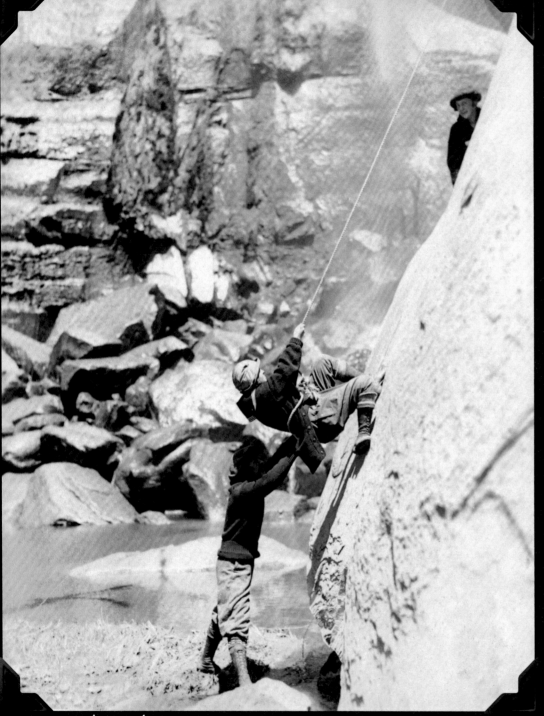

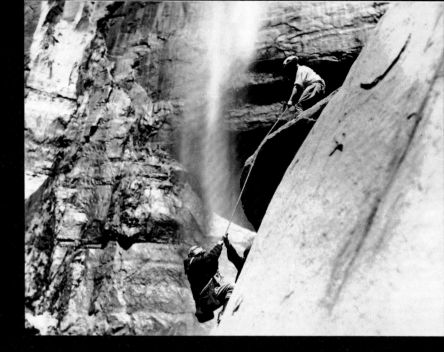

Opposite, far left, with Mildred Gerrard pushing, Nell Creer goes up and Anna Widtsoe can be seen at the top. Top left, Fred Coffey helps pull Nell Creer up. Bottom left, Nell Creer and Melba Dunyon on the rope. Right, Melba Dunyon assists Anna Widtsoe in her descent at Weeping Rock.

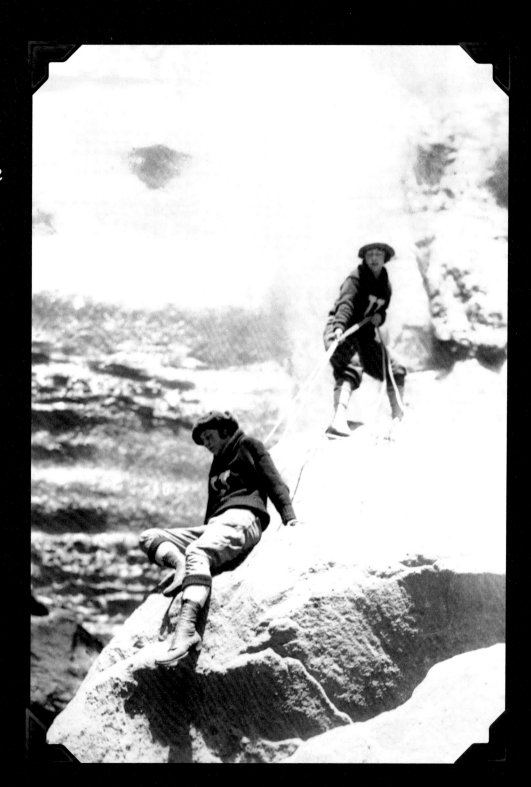

WEEPING ROCKS

Monday morning, May 10, after breakfast, the university girls hiked up to the "falls directly back of camp and then on up to the cable," Anna Widtsoe said. "A long hard climb and walk."[1]

The cables were originally built to carry lumber from the rim to the canyon floor, but soon after Zion became a national monument, people began riding the cable for amusement. "The cables go up for over a half mile," Anna mused.[2] The girls hoped to be given a ride on the precarious device, but were never allowed to take the dangerous ascent. Later in the week, however, the girls would visit the lumber camp on the rim above the cables, arriving there by some other means.[3]

From the cables they went to Weeping Rock. "The most wonderful waterfall," Anna praised. "An amphitheater, sort of, and on practically solid rocks, to see ferns, moss and flowers growing."[4]

The girls spent little time there on Monday. They returned, however, for an extended stay the following day. "We spent a great deal of time by 'Weeping Rocks,' getting beneath the falls and having our pictures taken," Anna wrote on Tuesday.[5]

"At the Weeping Rocks...they found one great cataract, dropping from the rim to a crystal clear pool hundreds of feet below," Eyre Powell reported. "A wet dash through the spray, aided down a slippery surface by their ropes, brought the girls to the miniature lake. It was here that two of them were treated to a thorough and unexpected shower bath as they sunned themselves on a boulder. The rock was where the cataract should have been falling," Powell continued, "but the wind had, for an hour or more, blown the water far to one side. Then suddenly the wind died down and the falls came back. There was an immediate rush for drier territory."

"On climbing out the way was blocked by the smooth surface of a huge rock, easy sliding going down but unscalable in the opposite direction," Eyre Powell said. "Finally, one of the 'exploresses' discovered a tunnel-like hole beneath it. It was a tight squeeze through, but all made it."[6]

Miss Nell Creer of Salt Lake and Fred Coffey of Los Angeles at Weeping Rock Falls, Zion National Park.

Los Angeles Sunday Times -July 25, 1920

Above, Dora Montague and Mildred Gerrard lay out to dry after being treated to an unexpected shower bath. Right, Anna Widtsoe and Melba Dunyon sun themselves on a rock.

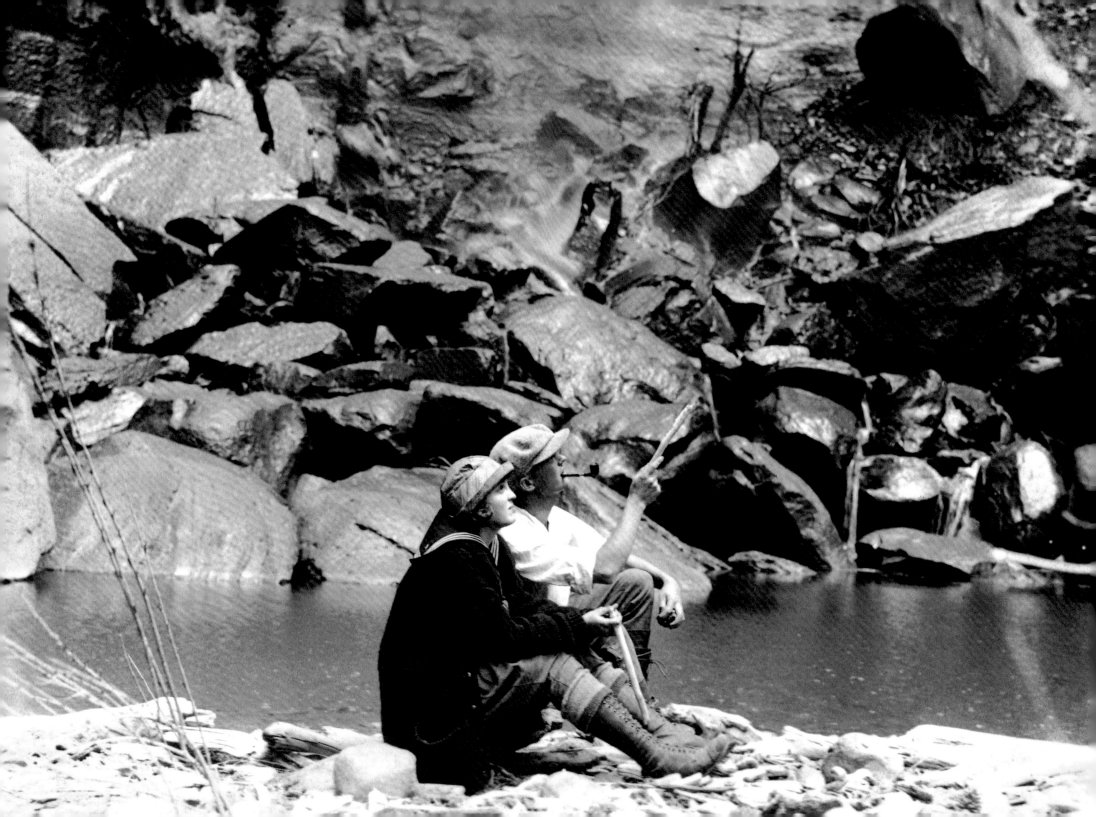

REACHING NEW HEIGHTS

Anna Widtsoe still wasn't feeling very well on Monday. "After lunch, I went to bed. I sure was sick. Cold and everything," Anna lamented. While she rested, the rest of the gang went hiking. Mrs. Peterson tried to get her to take some Epsom salts which she flatly refused. After a "lovely dinner" and singing around a bonfire, the girls retired early on their first full day in the park.

The next day, things were looking up for Anna. "Tuesday, we made for the cables early. I felt better—wouldn't say if I didn't," she wrote enthusiastically. In addition to their second visit to Weeping Rock, the coeds spent the morning near the Great White Throne, Angels Landing, and the Organ. "Spent [a] lovely time on the rocks scrambling around," she said. "After lunch we [hiked] again up to the falls back of the camp only up farther than before."[1]

According to Eyre Powell, the girls explored a "hanging valley" that was straight up the cliff above Camp Wylie. "In it was found the source of the stream which supplies the much pictured, veil-like waterfall which gushes over a gayly striped ledge into a little circular glen in the rock a hundred feet below," Powell reported. "They followed the stream to where it sprang from the great red cliff in the center of an amphitheater fitted up theaterlike by nature, with balconies and galleries all etched out of the living rock."[2]

Though not mentioned by name in the story, the falls and amphitheater described by Powell are most likely the area now called the Emerald Pools.

"Far above, three of the girls, Ann Widtsoe, Dora Montague and Nell Creer, reached a point never before gained," Eyre Powell said. "Here the altimeter carried by Miss Widtsoe registered an altitude of 4,900 feet, a sheer 700 feet over the valley floor, the highest ever climbed on the abyss wall.

"This was in the nature of a coup on their fellow exploresses, Miss Dunyon, Catherine Levering, Mildred Gerrard and Mrs. Peterson," Mr. Powell said.[3] He claimed that they were occupied with the exploration of a cave they had found, but according to Anna Widtsoe, they were quite busy elsewhere. "During our afternoon hike, Melba, Mildred, [Catherine] stayed home and fixed the fellows beds so they couldn't get in until they had made their bed all over again."[4] This was only the beginning of several pranks played by the group in the days to come.

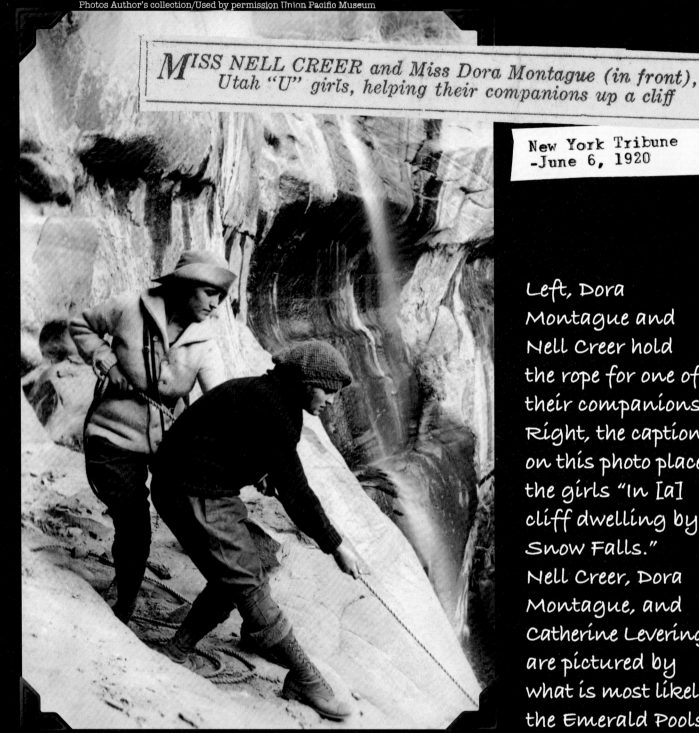

MISS NELL CREER and Miss Dora Montague (in front), Utah "U" girls, helping their companions up a cliff

New York Tribune -June 6, 1920

Left, Dora Montague and Nell Creer hold the rope for one of their companions. Right, the caption on this photo places the girls "In [a] cliff dwelling by Snow Falls." Nell Creer, Dora Montague, and Catherine Levering are pictured by what is most likely the Emerald Pools.

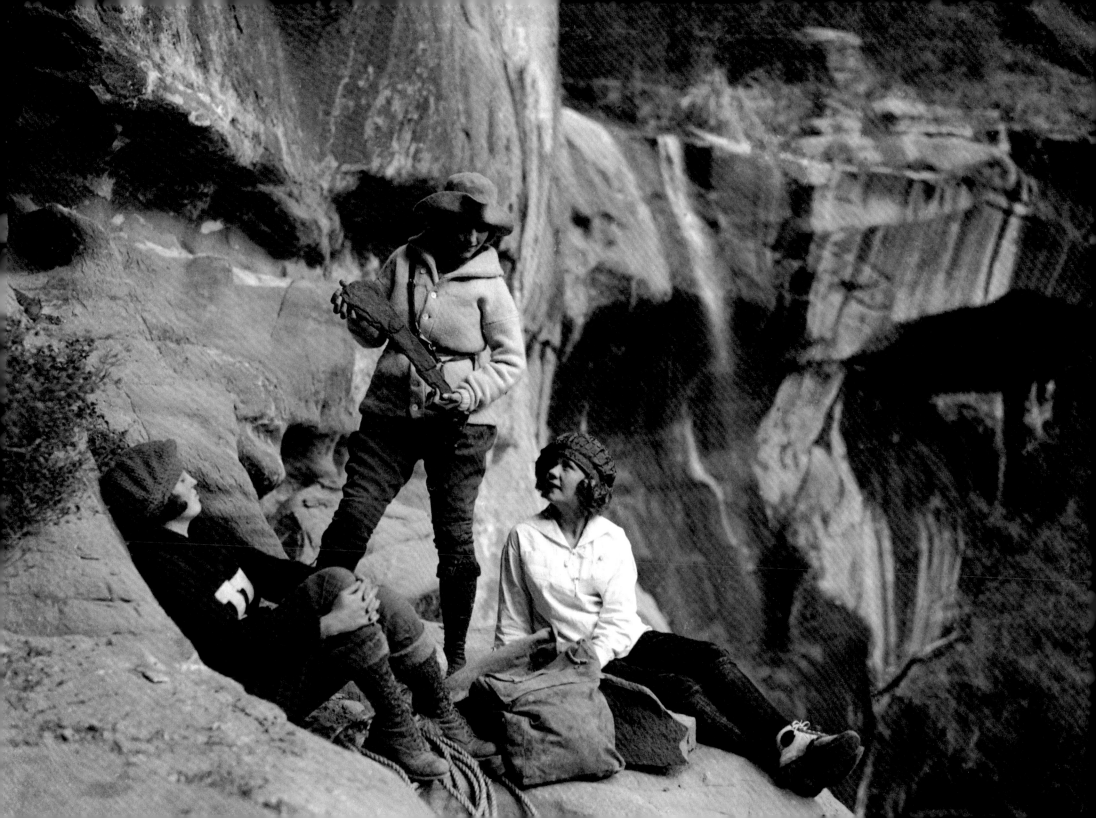

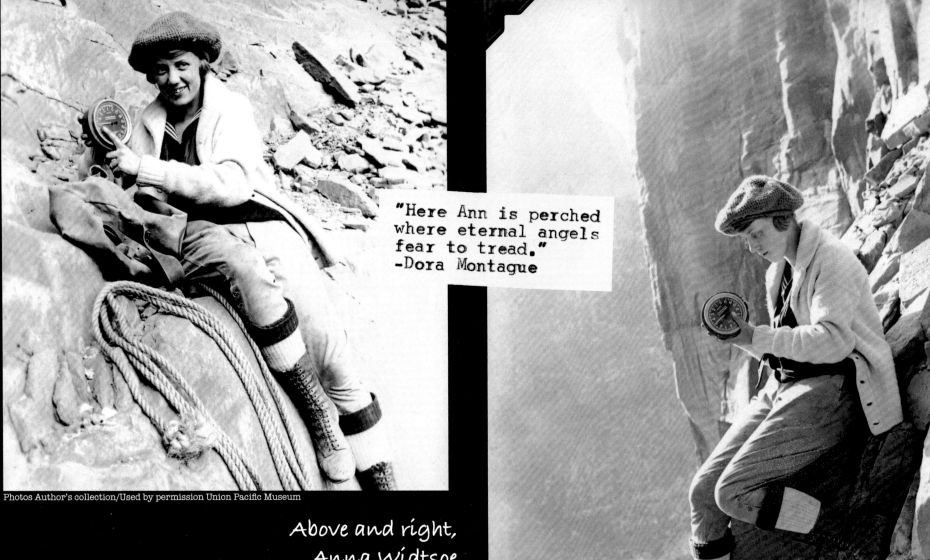

"Here Ann is perched where eternal angels fear to tread."
-Dora Montague

Above and right, Anna Widtsoe records reaching new heights with an altimeter.

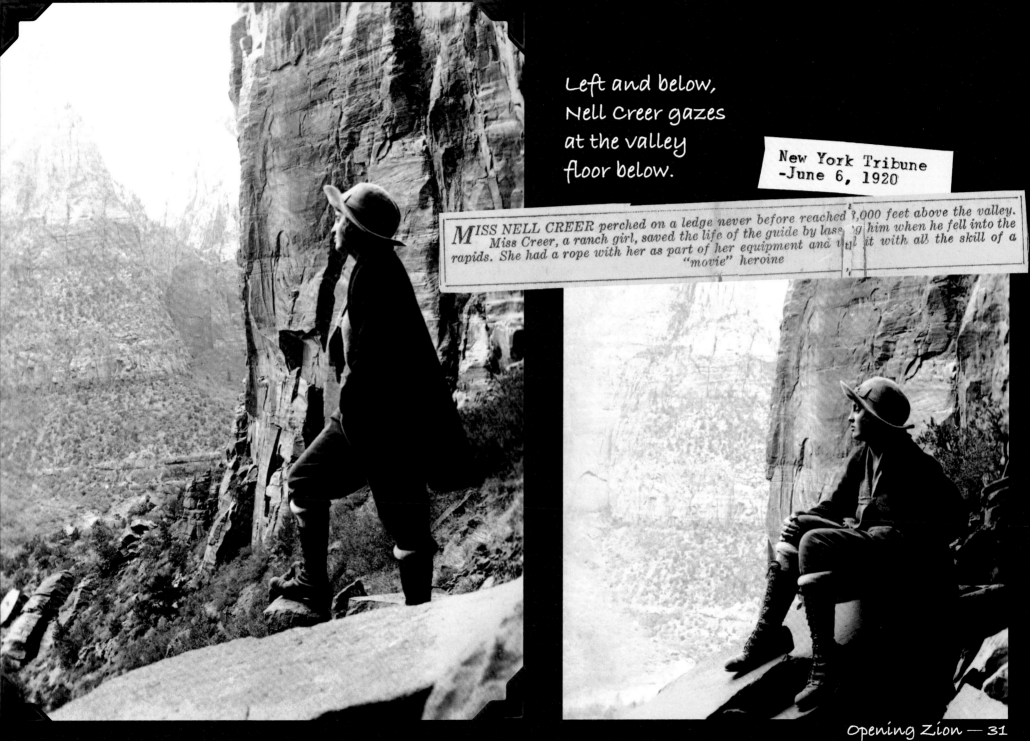

Left and below,
Nell Creer gazes
at the valley
floor below.

MISS NELL CREER perched on a ledge never before reached 3,000 feet above the valley. Miss Creer, a ranch girl, saved the life of the guide by lass[..]g him when he fell into the rapids. She had a rope with her as part of her equipment and u[..]il it with all the skill of a "movie" heroine

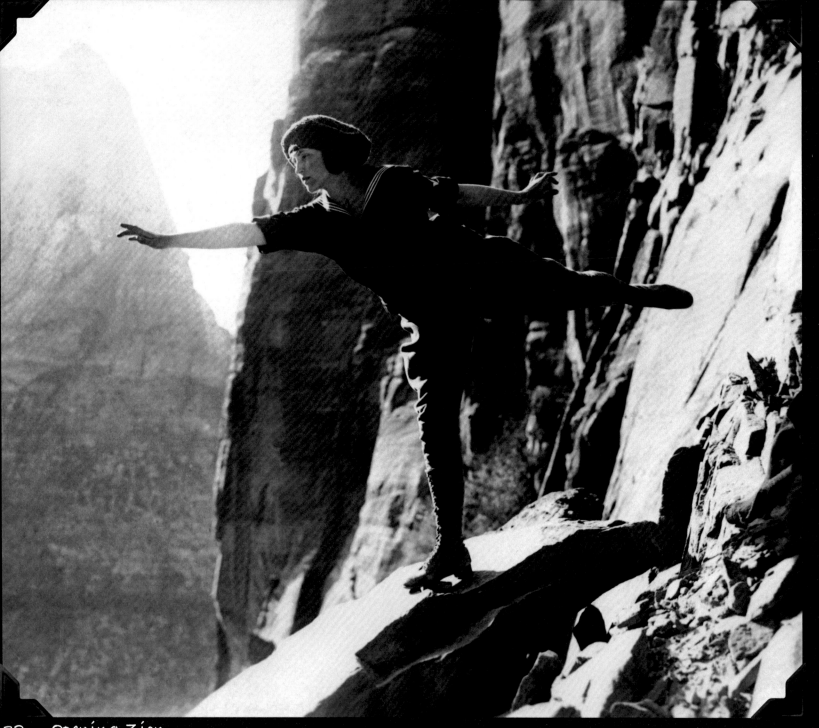

Left, Dora Montague performs a stunt as a "Flying Dutchman." Right, Dora calmly sketches the scenery while hanging over a Zion chasm.

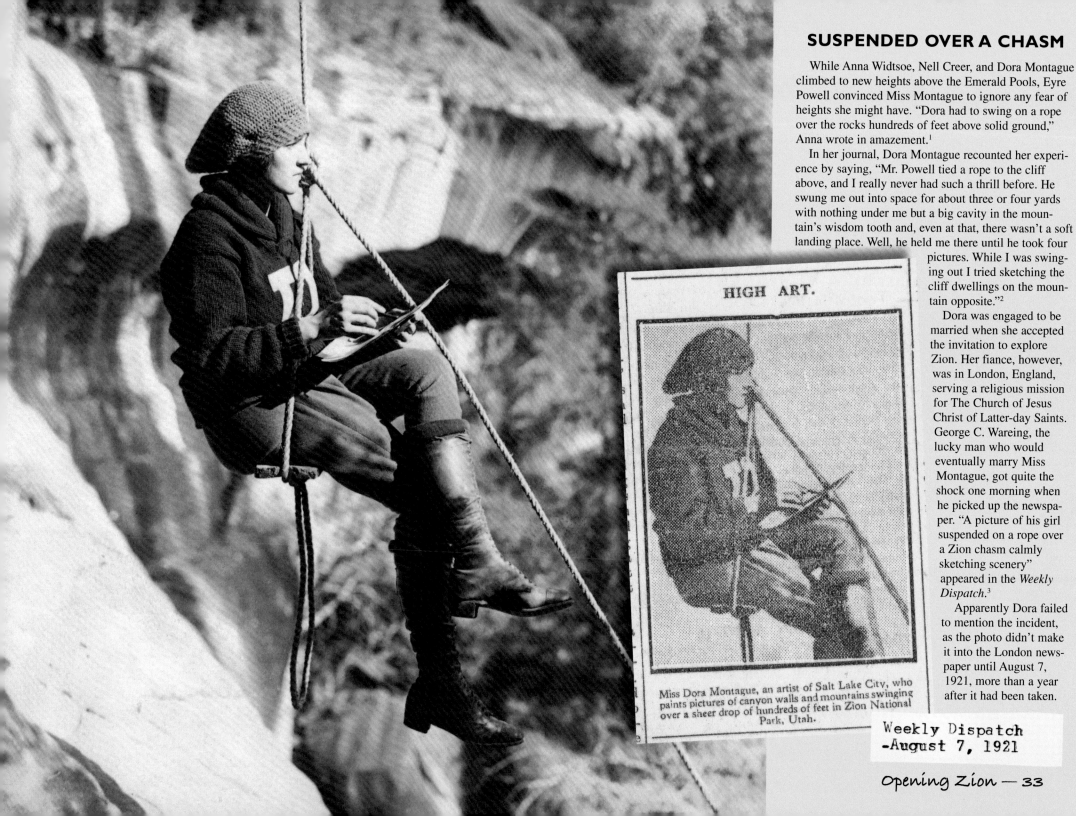

SUSPENDED OVER A CHASM

While Anna Widtsoe, Nell Creer, and Dora Montague climbed to new heights above the Emerald Pools, Eyre Powell convinced Miss Montague to ignore any fear of heights she might have. "Dora had to swing on a rope over the rocks hundreds of feet above solid ground," Anna wrote in amazement.[1]

In her journal, Dora Montague recounted her experience by saying, "Mr. Powell tied a rope to the cliff above, and I really never had such a thrill before. He swung me out into space for about three or four yards with nothing under me but a big cavity in the mountain's wisdom tooth and, even at that, there wasn't a soft landing place. Well, he held me there until he took four pictures. While I was swinging out I tried sketching the cliff dwellings on the mountain opposite."[2]

Dora was engaged to be married when she accepted the invitation to explore Zion. Her fiance, however, was in London, England, serving a religious mission for The Church of Jesus Christ of Latter-day Saints. George C. Wareing, the lucky man who would eventually marry Miss Montague, got quite the shock one morning when he picked up the newspaper. "A picture of his girl suspended on a rope over a Zion chasm calmly sketching scenery" appeared in the *Weekly Dispatch*.[3]

Apparently Dora failed to mention the incident, as the photo didn't make it into the London newspaper until August 7, 1921, more than a year after it had been taken.

HIGH ART.

Miss Dora Montague, an artist of Salt Lake City, who paints pictures of canyon walls and mountains swinging over a sheer drop of hundreds of feet in Zion National Park, Utah.

Weekly Dispatch
-August 7, 1921

RAGING RIVER

"During the summer season the ride to the Narrows, up which lay the mysterious mountain, is easy, with shallow fords and excellent trail," Eyre Powell wrote for the *New York Tribune*. "But at this time, with melting snow on the plateaus high above pouring torrents into it, the stream was high and swift." The party of explorers used caution when fording the raging river. "Every crossing had to be made with care," Powell said, "the equipment first and then, in relays, the maids."[1]

Despite their best efforts, mishap could not be entirely avoided. One of the men (who remained unnamed) volunteered to show the girls a proper ford when he fell into the swift Virgin River. Nell Creer didn't hesitate to rescue this "mere man." "[She] was reared on a big cattle ranch, and her skill with a lariat aided materially," Eyre Powell observed. "He was noosed and hauled out in short order before he had been carried 50 yards."[2]

Horses were pressed into service as "four-legged ferries" to help the party of explorers cross the churning waters of the Rio Virgin. "It's great sport," Dora Montague commented. "The water came way up to our saddles and we had to put our feet up so they wouldn't get wet. It surely is a sight to see those dear horses plodding through the river with the loads on their backs and the beautiful colored mountains for a background!" Crossing the river four times, the party rode the horses up to the Temple of Sinawava.[3]

A spring storm caught the already wet explorers while in the Temple of Sinawava, forcing them to seek shelter beneath a pair of stone pillars. Once the downpour abated, they left the horses and "took to the sides of the canyon," continuing on foot toward the Narrows. "Here in many places the ropes came into play again in real Alpine style," Eyre Powell said, "until finally the portion of the gorge where the walls approach within a half-dozen yards of each other was reached."

"But, past the entrance the girls found the going impossible," Powell continued. "The stream had been fordable in the wider parts of the canyon, but it was compressed into such a narrow bed here that nothing could stem its current and they had to turn back." The raging river was finally too formidable, the water was more than 10 feet deep. "A week or so later the water will have subsided so that the 'wet trail' through the Narrows will be entirely 'navigable' and then they will try again," Powell concluded.[4]

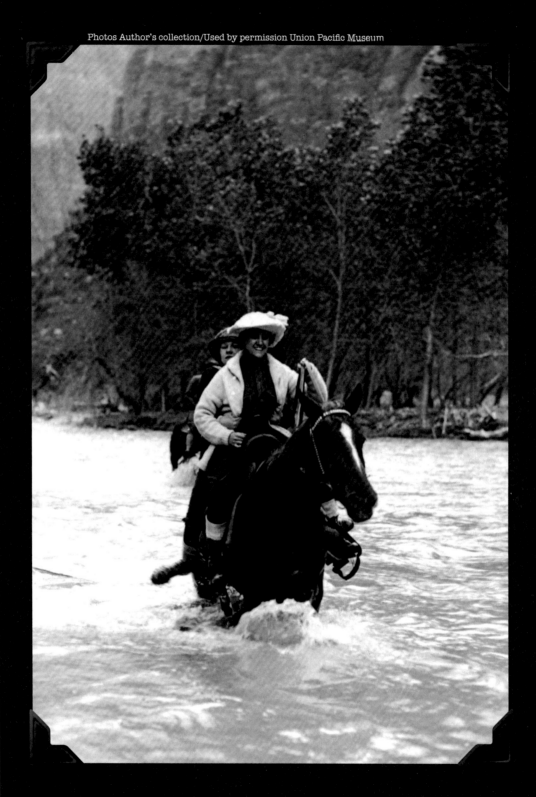

Left, Mrs. Pete and Catherine Levering ford the Virgin River on their four-legged ferry. Right, Fred Coffey and Anna Widtsoe, and Al Pyper and Melba Dunyon. The churning waters of the Virgin appear as white as snow.

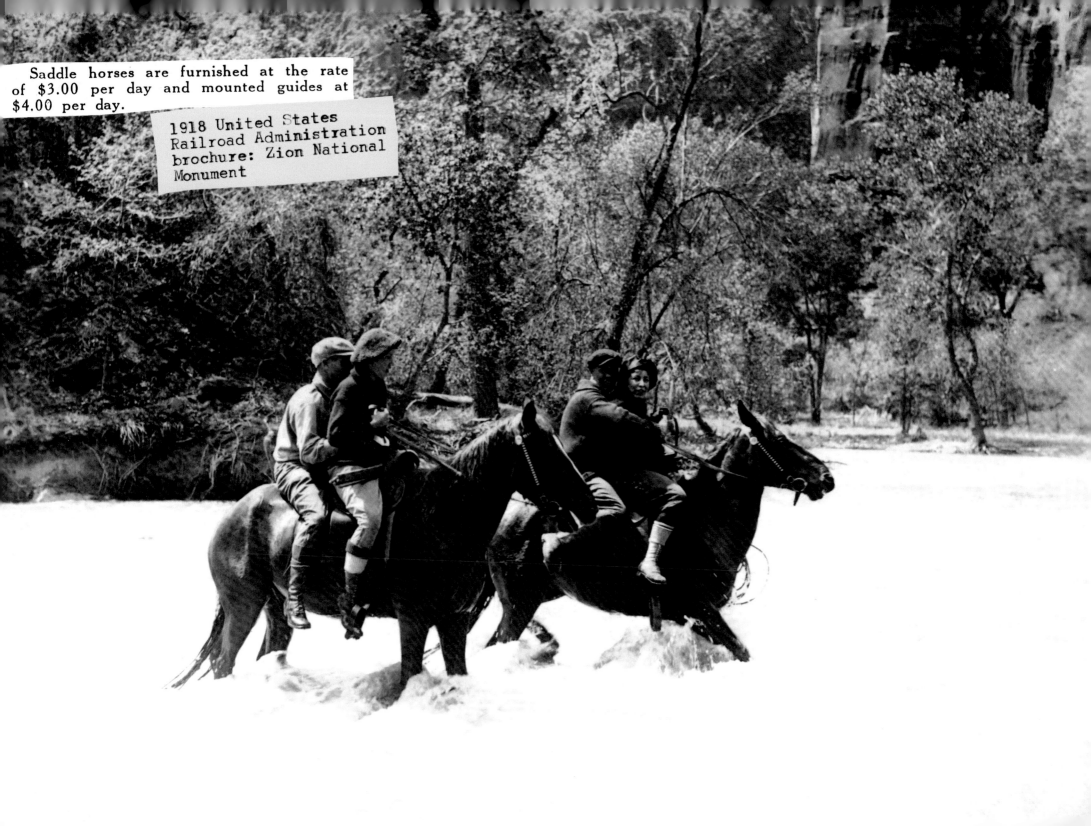

Saddle horses are furnished at the rate of $3.00 per day and mounted guides at $4.00 per day.

1918 United States Railroad Administration brochure: Zion National Monument

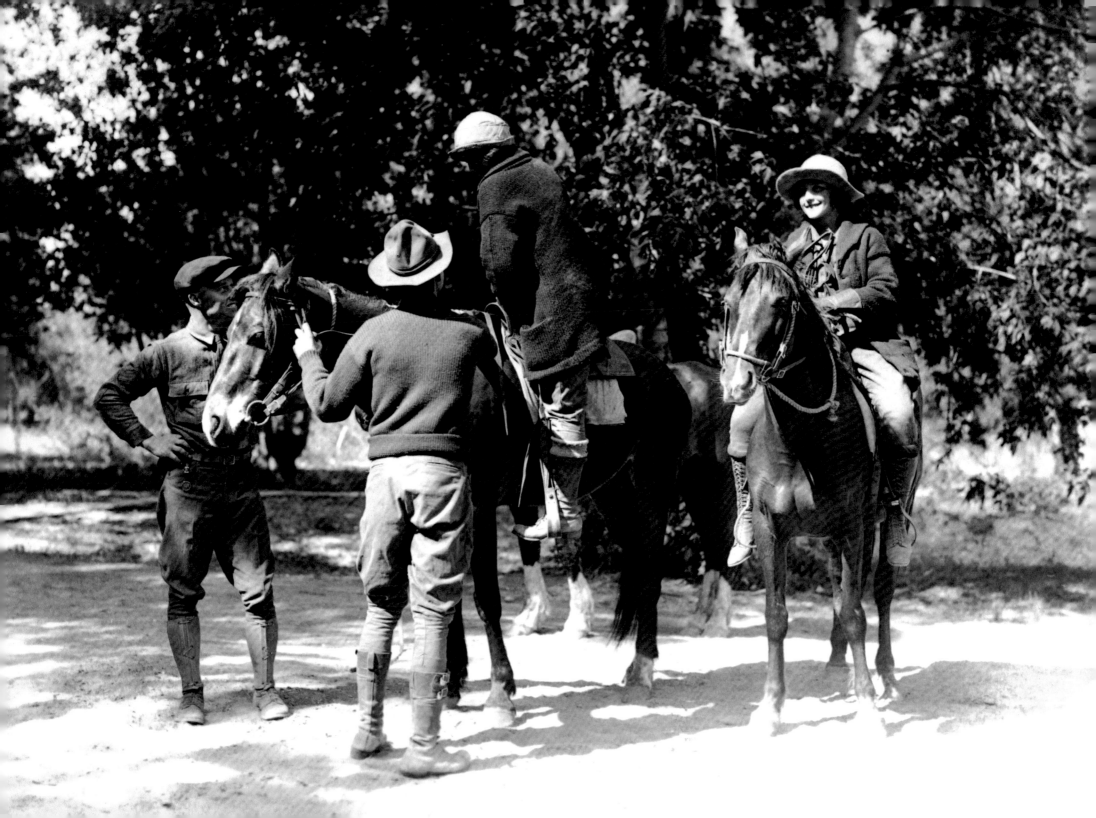

Opposite, Al Pyper, Chauncey Parry, Nell Creer, and Dora Montague saddle up. Below, the explorers travel upstream on horseback.

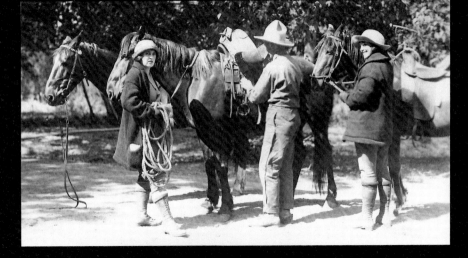

Left, Nell Creer (left) and Dora Montague are assisted by a "camp boy." Below, Dora and Nell.

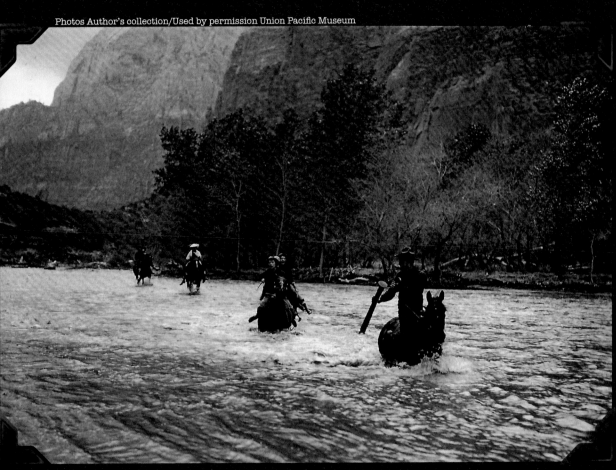

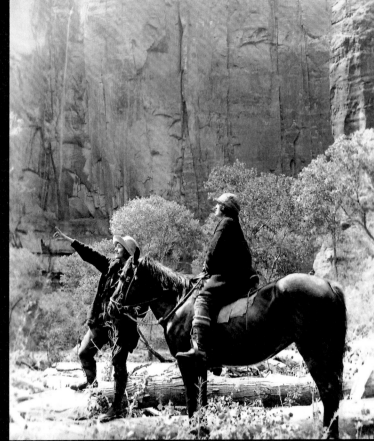

Right, Nell Creer and Chauncey Parry gaze at the grandeur of the Temple of Sinawava.

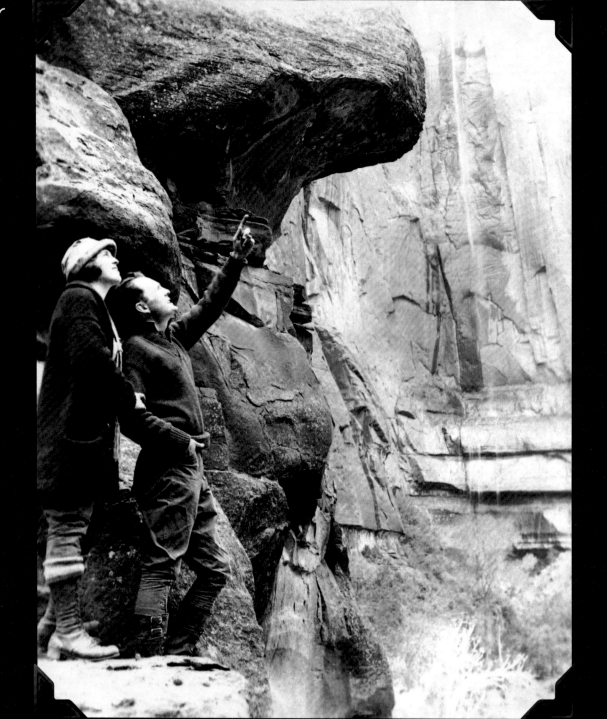

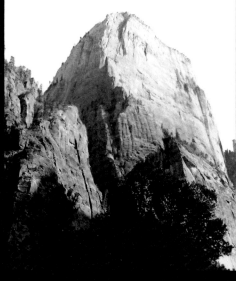

Above, The Great White Throne towers over the valley floor. Right, Pulpit Rock near the Temple of Sinawava.

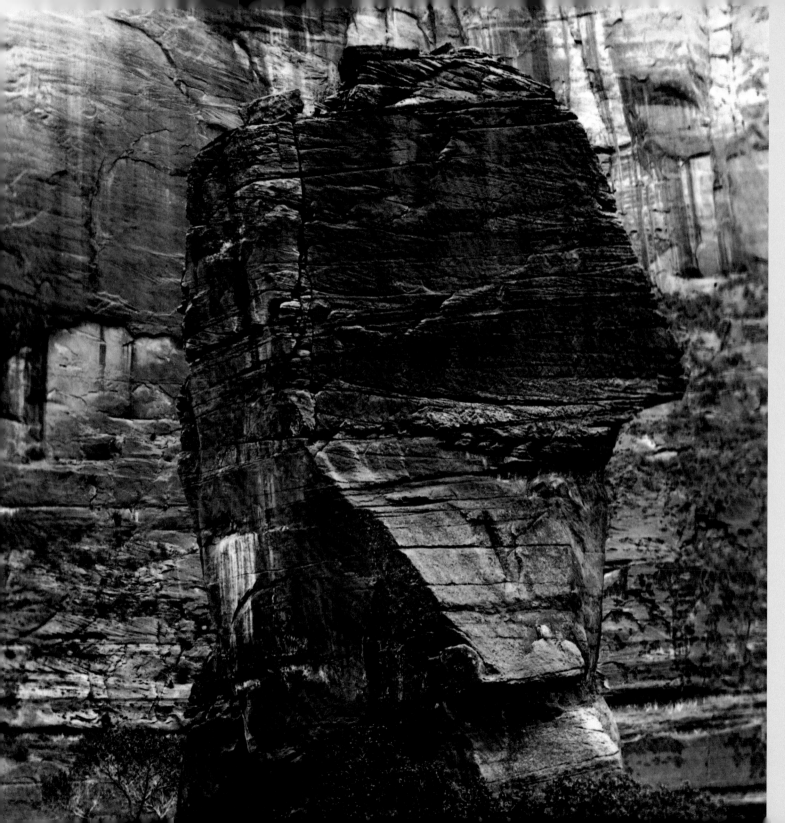

GREAT STONE FACES

"There is a place called 'The Hanging Valley,'" Dora Montague wrote in her journal, "that goes way back into the side of the mountain."[1] Eyre Powell said that the "U"girls found a beautiful verdant alcove which he said had never been entered. "It is a garden of bowered trees, ferns and flowers," Powell said, that rested on a shelf above the Temple of Sinawava and was in plain sight of the main canyon trail. Even though Anna Widtsoe discovered a way to the valley, Eyre Powell said "it [would] be the objective of another trip."[2]

"On the walls of the mountains are natural hanging gardens of the most beautiful green grass and colored flowers," Dora Montague remembered. "We ran across the most beautiful bed of wild flowers. Yellow snap-dragons and lavender violets and red honeysuckles amid wild climbing grapevines and bushes."

In contrast to the fragile beauty of the flowers, Dora marveled at the grandeur of the towering Great White Throne. "There it stood in its great white splendor look-ing down into the valley. A hill, shaped like a quarter moon, of brown rock, made a contrast in color. It seemed as if the Creator had just formed it that way to make a beautiful picture."

Dora was also stirred by the Temple of Sinawava's stone walls: "It reminded me of a great amphitheater and made me realize how infinitesimally small we humans really are."

"Mountain watching" inspired Dora to look beyond mere rock. "At first I could see just a mountain. Then, as I looked, other things began to form. It seemed as if they were really human and the expressions on their great stone faces seemed to change and become more and more beautiful. I found it ever so much more inter-esting than lying on my back gazing at clouds."[3]

Anna Widtsoe expressed similar thoughts while admiring Zion's towering cliffs. "Going down the canyon it was just magnificent. Such gorgeous huge mountains I don't ever expect to see again. The three patriarchs, Abraham, Isaac and Jacob were beautiful."

"The mountains are just marvelous," Anna said while entranced by their beauty. "You can sit and gaze at them and imagine all sorts of things—picture different things from the massive rocks."[4]

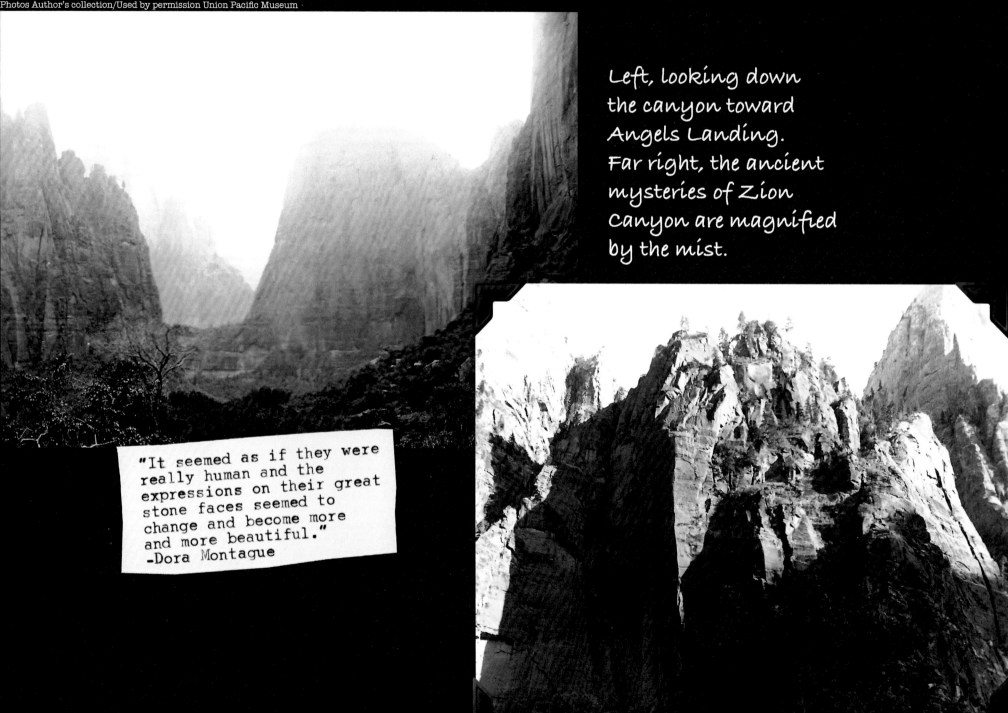

Left, looking down the canyon toward Angels Landing. Far right, the ancient mysteries of Zion Canyon are magnified by the mist.

"It seemed as if they were really human and the expressions on their great stone faces seemed to change and become more and more beautiful."
-Dora Montague

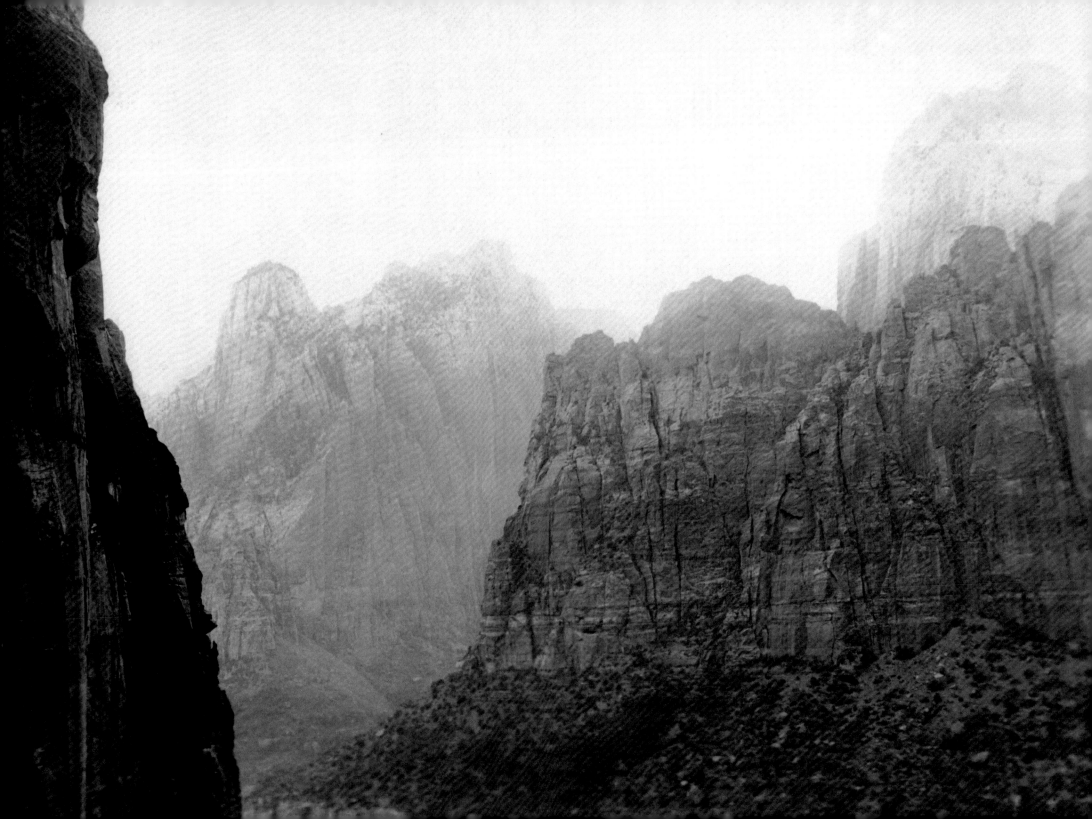

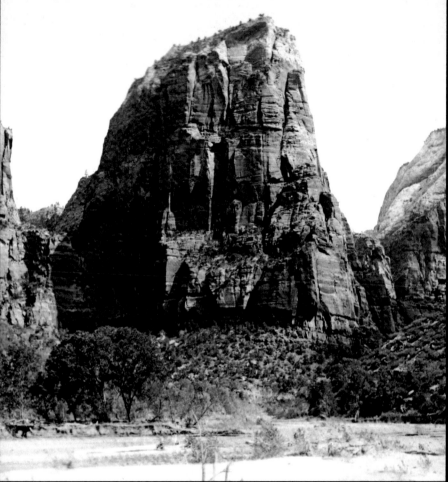

Above, Angels
Landing. Right,
waterfall in the
Temple of Sinawava.

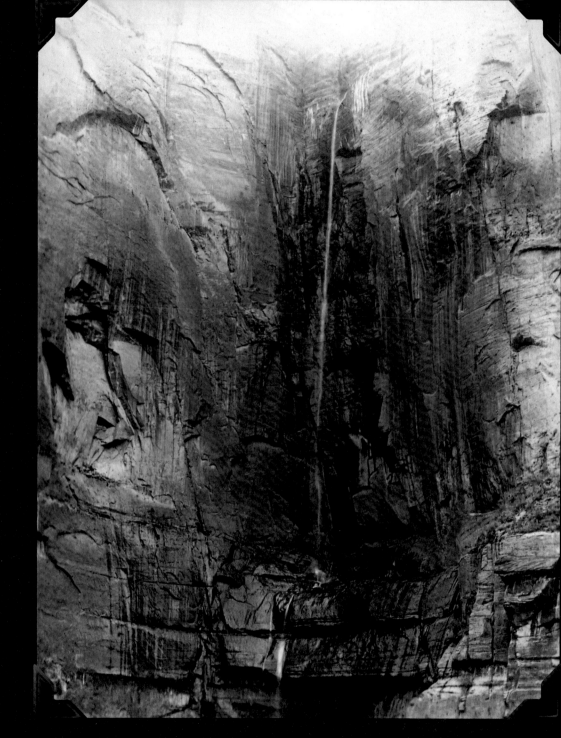

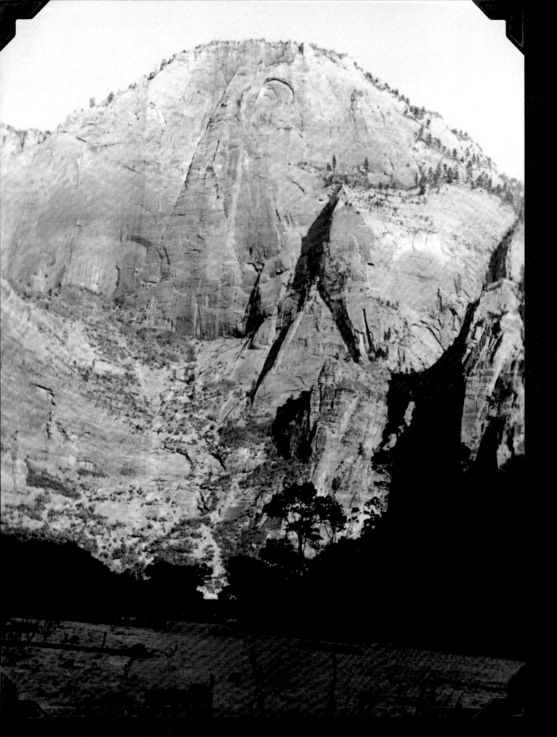

Left, Cable Mountain. Below, the Great White Throne.

CANYON TOGS

"They officially opened [Zion's] first year as one of America's greatest national parks," Eyre Powell said. "But more important, especially to the feminine reader, they established firmly the 1920 styles in outing togs for thousands of American women who will spend the summer in the great outdoors."

"They tried out almost everything in wearables during the trip and under every condition met with in a summer's outing," Powell continued. "From the ordinary routine of the average tourist living in a well ordered hotel camp and riding or walking to points of interest, to more strenuous life of really roughing it, the 'U' girls gave their costumes the most severe tests. Here is their verdict as to the prettiest and most practical outing garb, and it's a verdict straight from headquarters, too; they know! It has been called the 'Zion Park' outfit and is already being widely copied."

Eyre Powell reported that no skirts would hinder the "well dressed outing girl," saying they were too dangerous for climbing hills or wading through streams. "For walking they found breeches of a military cut neat, but for climbing and general freedom of action knickerbockers, roomy at both hips and knee, were found vastly preferable by the 'U' girls who wore them and so became the choice in selecting the Zion Park costume."

Footwear was also covered in Powell's description of the perfect "Zion Park" outfit. "Half-high boots of stout construction are the thing, they declare, preferably with hobs or Swiss nails."

"Two pair of hose are the best," Powell suggested, "the outer ones with a fancy top rolling down between the top of the boot and the knickers and the under ones of a finer quality for comfort."

Finally, Powell described what top and hat would complete the ensemble. "A middy or outing shirt, as one prefers, with a tam-o'-shanter to top everything off complete the outfit."

Of course, no outfit was complete without accessories. "For use in the remote parts of the National Park, which are not accessible to the automobiles or saddle horses of the usual tourists," Eyre Powell said, "the university maids carried packs, and coils of well tried rope."[1]

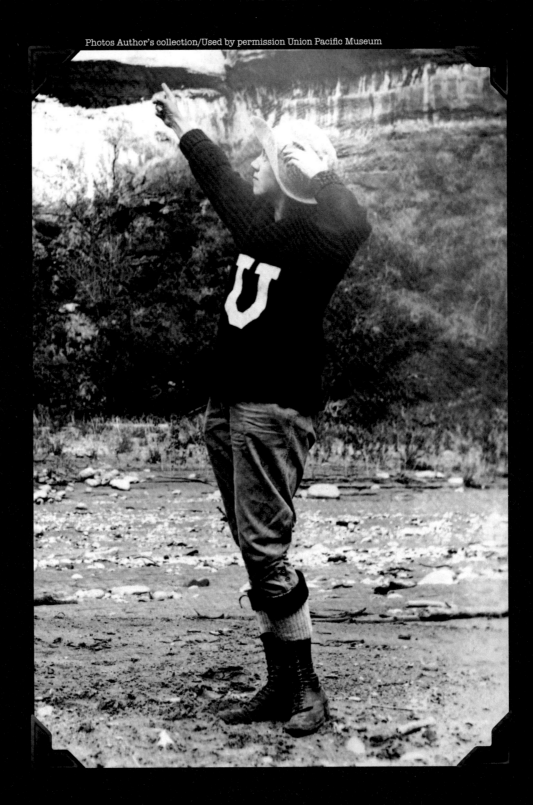

Anna Widtsoe (left) and Melba Dunyon (opposite) show off their hiking outfits complete with University of Utah sweaters.

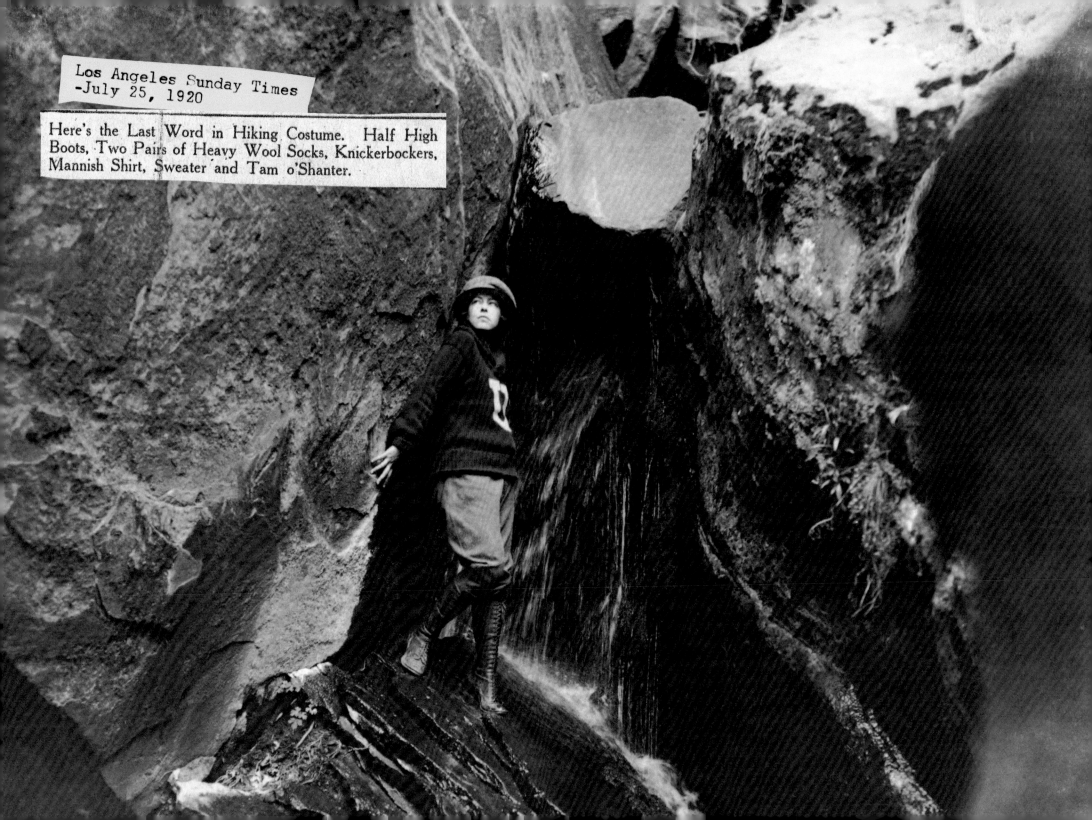

Los Angeles Sunday Times
-July 25, 1920

Here's the Last Word in Hiking Costume. Half High Boots, Two Pairs of Heavy Wool Socks, Knickerbockers, Mannish Shirt, Sweater and Tam o'Shanter.

Dora Montague

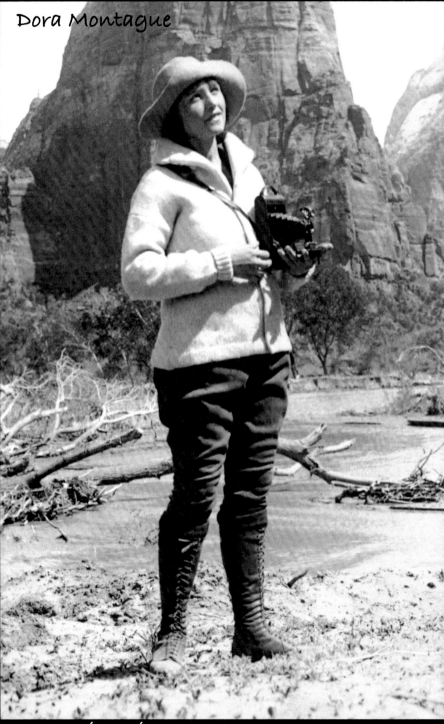

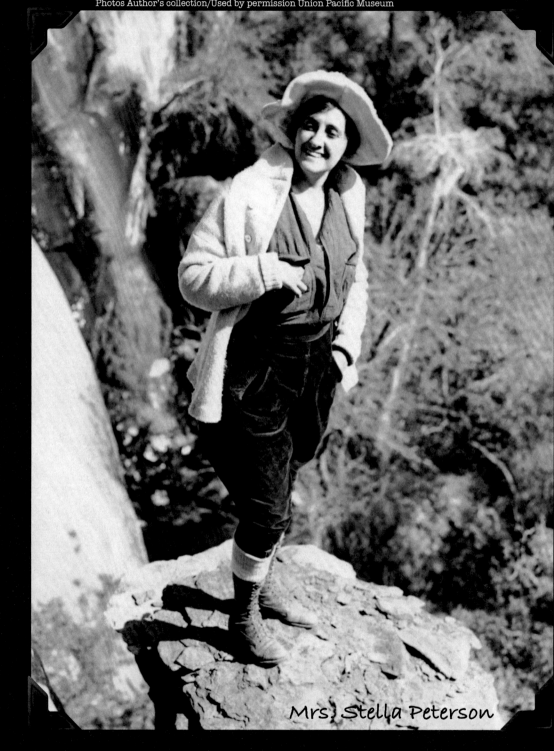

Mrs. Stella Peterson

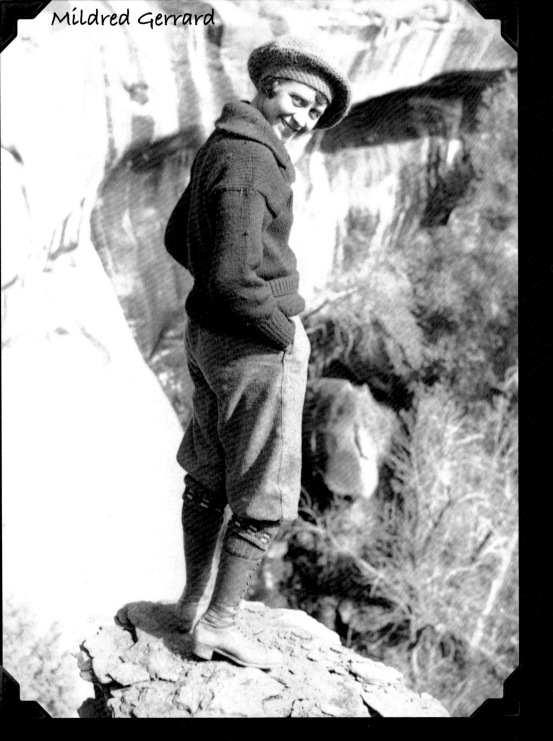

Mildred Gerrard

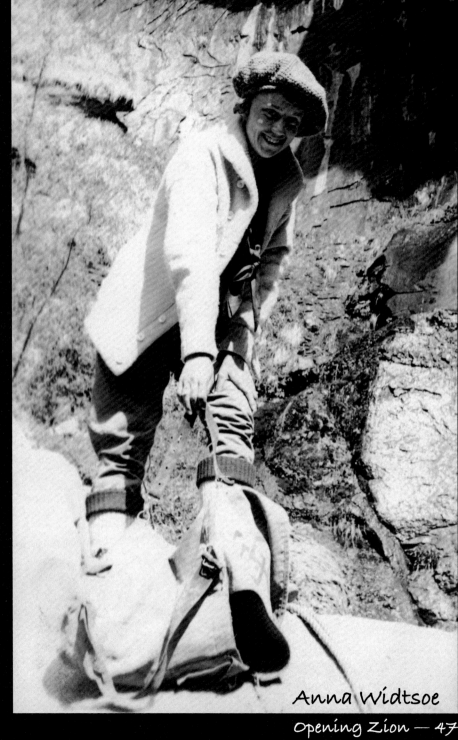

Anna Widtsoe

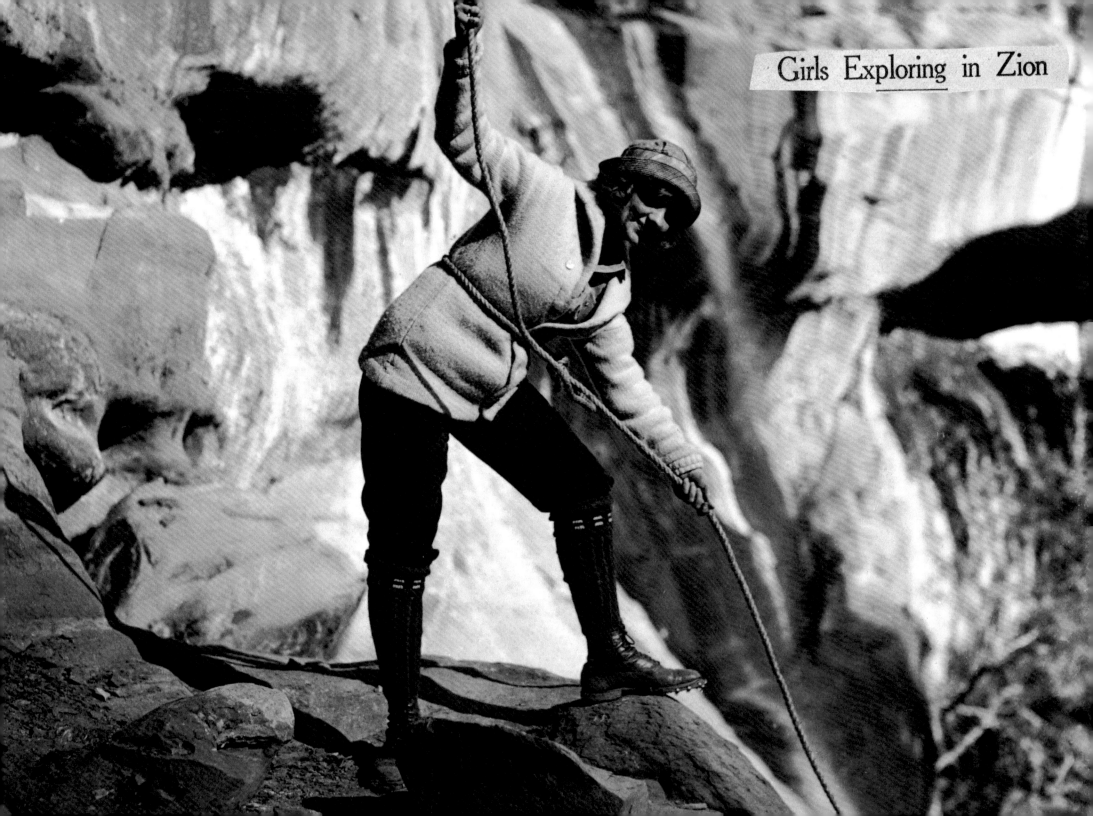

Catherine Levering (left), Mildred Gerrard and Melba Dunyon (right), and Anna Widtsoe (below) complete their "Zion Park costume" with packs and ropes.

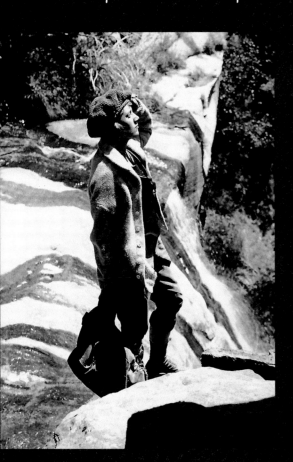

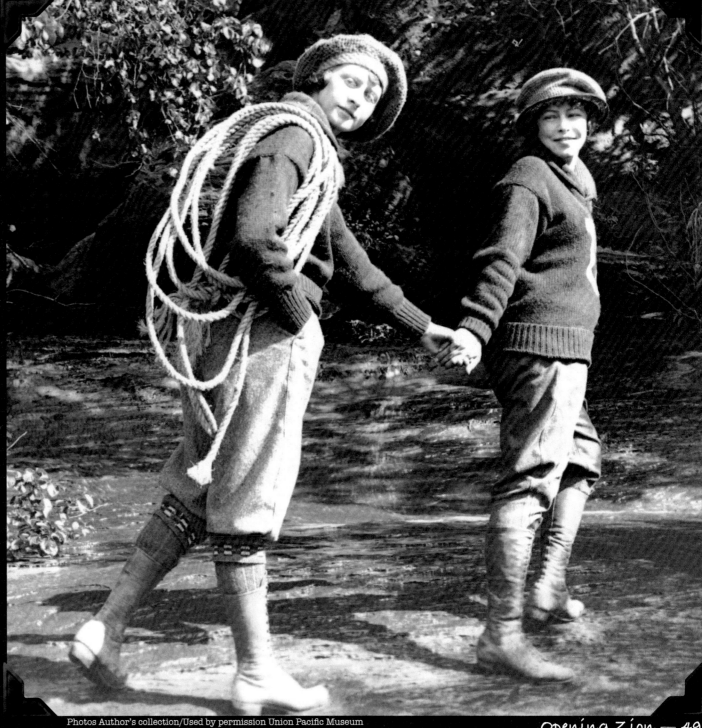

Right, Mildred Gerrard in deep meditation. Below, Anna Widtsoe coming through. She is assisted by Nell Creer.

Opposite, Melba Dunyon saves Nell Creer from falling down a slippery slope. Below, Melba discovers a tear.

MISS ANN WIDTSOE, daughter of the president of Utah University, making the last stage of a difficult climb

Photos Author's collection/Used by permission Union Pacific Museum

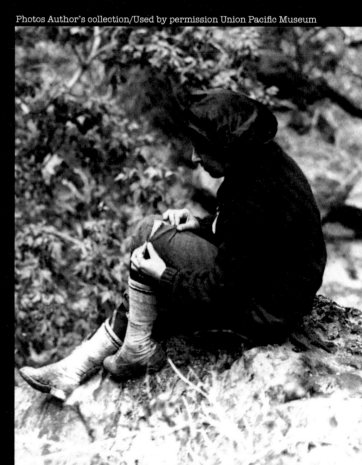

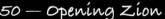

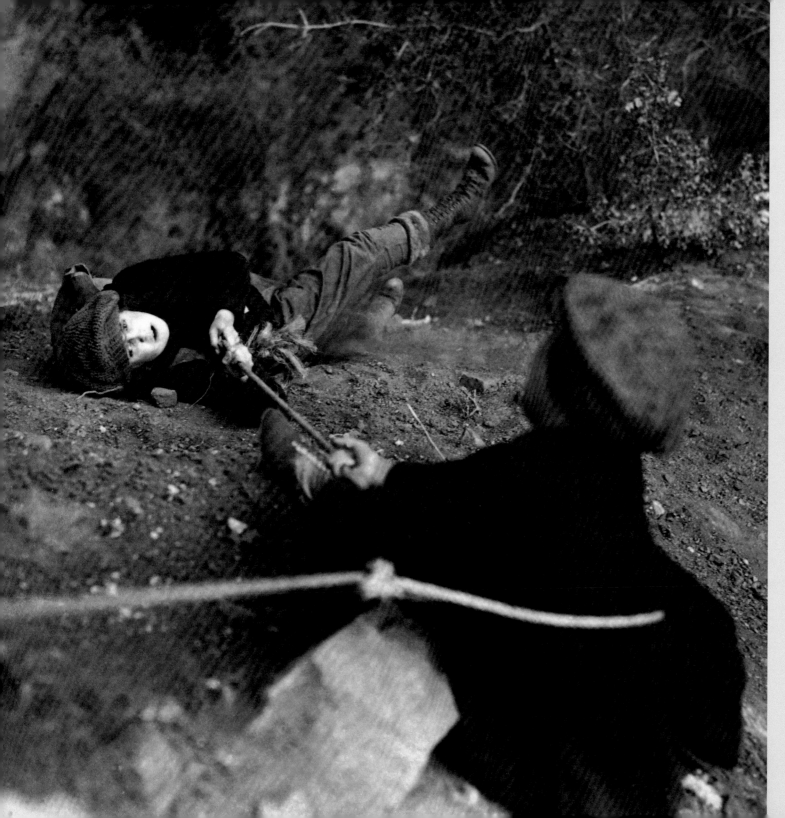

SCRAMBLING ON THE ROCKS

Equipped with "real Alpine climbing togs," ropes, and the latest in climbing gear, the university girls expected to explore "the innermost stretches of the park as well as its more traveled portions. …They expect to reach many places in the Utah wonderland which as yet have been seen by only a few of the most venturesome."[1]

The adventurous hikers did in fact climb into crevices and crawl into spaces no longer accessible to the public. "Thursday we started early with our lunch for the 'Narrows,'" Anna Widtsoe said. "On our way we stopped at a cave dwelling and had pictures taken. It was dangerous but fun."[2] In 1920, the most advertised ancient ruins were those located in Parunuweap Canyon, "seven miles above the confluence of the two creeks."[3]

"Two hundred feet above, up in the side of one of the canyon walls, was a great cave, once the home of a band of cliff dwellers, where remnants of their houses were still standing," Eyre Powell wrote. "The climb would have been a hard one, even for a man, but the girls made it in record time and remained for several hours among the relics of the past age."[4]

"We…saw how, in the dim past, the old cliff dwellers built their hiding places and homes in the mountain side," Dora Montague wrote in her journal. "Rock after rock put together by means of a plaster made of sand and water and mud formed the wall of the dwelling. Only parts of it remain to show how clever these men were," she said. "And to think they should build in such out of the way places! Evidently they believed in 'safety first.'"[5]

Even out-of-the-way places had their risks, though, especially on the day the hiking party climbed into the ancient ruin. Among the stone walls lay a pair of rattle snakes. Anna Widtsoe later claimed that she killed at least one of them with a rock and cut off its head. "I helped kill and then skinned two rattle snakes and brought [the] skins with me," Anna said. "Imagine me skinning snakes. 'Hard-boiled' is right."[6]

Snakes were the least of the climber's worries as they found themselves in numerous precarious positions. "At one place in ascending a steep shale slope above a narrow canyon in blazing a trail into one of the marvelous little hanging valleys," Eyre Powell recalled, "the rope became an actual life saver when, half way up, the top climber slipped, dragging the one in the center after her as she slid rapidly toward a steep drop. The second one had a chance to brace herself, however, and with the aid of the third at the other end of the rope brought their companion to a stop well within a safe margin."[7]

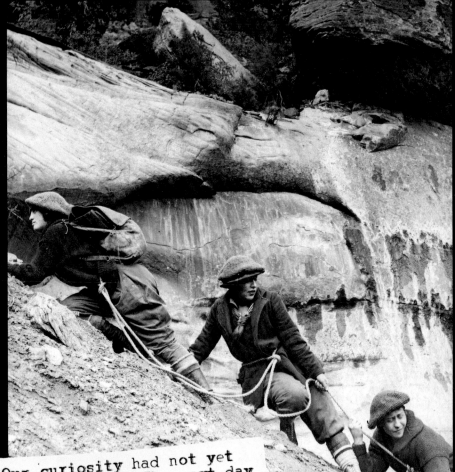

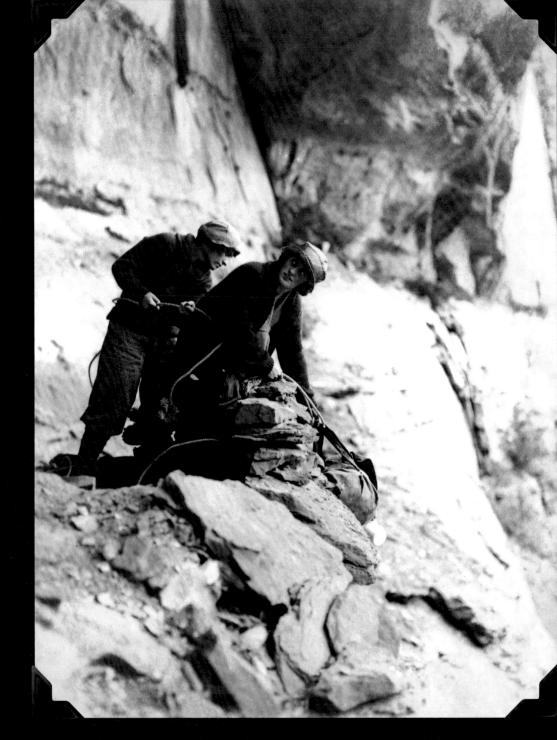

"Our curiosity had not yet been satisfied. The next day our restless spirits again to the hills."
-Dora Montague

Above, Nell Creer, Melba Dunyon, and Mildred Gerrard. Right, Dora Montague and Nell Creer let down the rope.

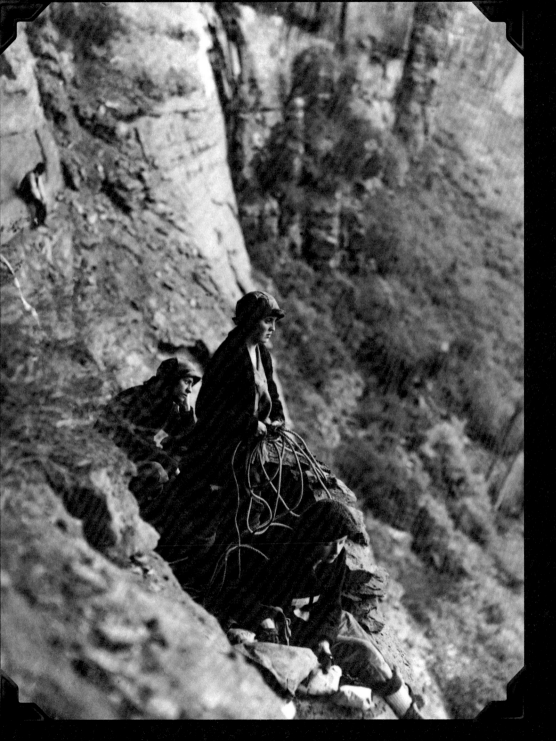

Left, Mildred
Gerrard, Nell
Creer, and Anna
Widtsoe rest on
a cliff.

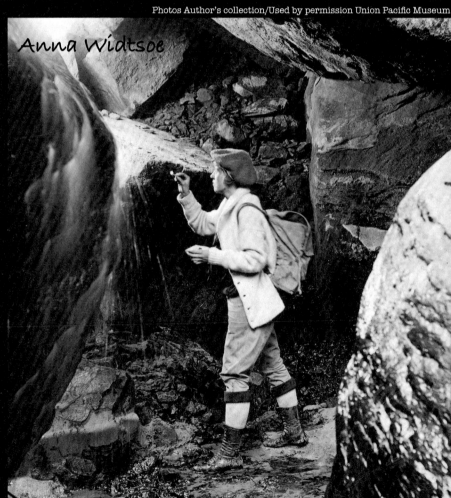

Anna Widtsoe

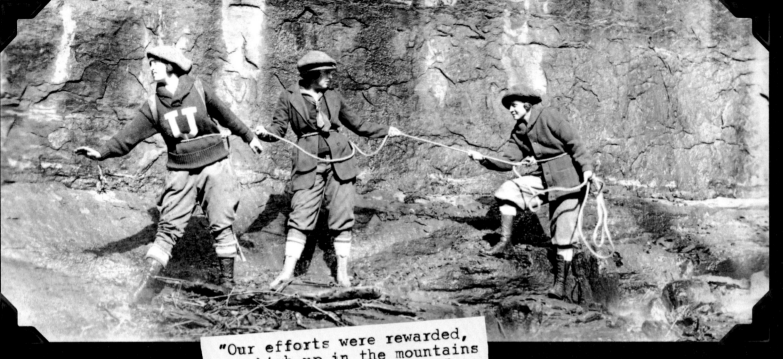

Opposite, Dora Montague, Eyre Powell, Mildred Gerrard, Mrs. "Pete," Melba Dunyon, and Anna Widtsoe climbing the rocks. Below, Anna Widtsoe and Fred Coffey are "Romeo and Juliet."

"Our efforts were rewarded, for high up in the mountains we found 'nature's cup.'"
-Dora Montague

Above, Dora Montague, Melba Dunyon, and Mildred Gerrard under the falls. Right, Nell Creer and Dora Montague discover a spring.

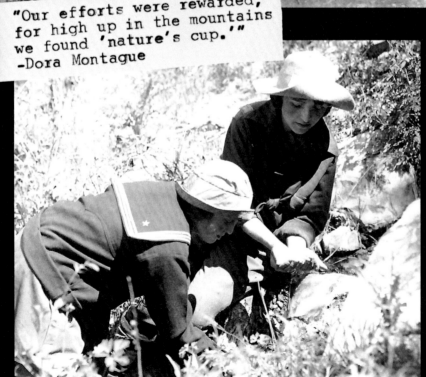

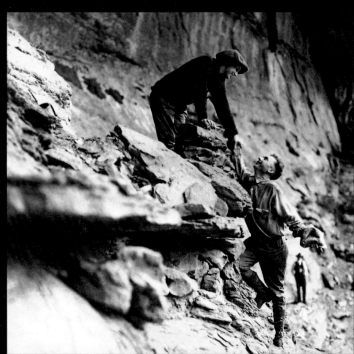

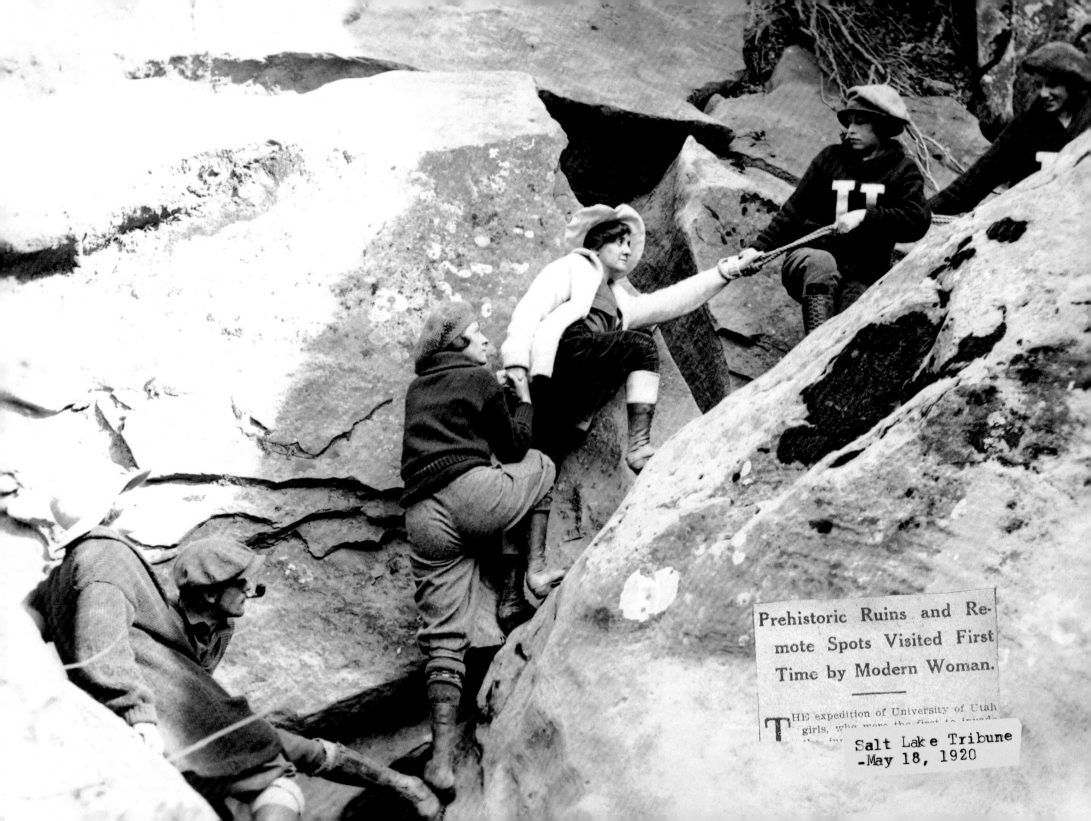

Prehistoric Ruins and Remote Spots Visited First Time by Modern Woman.

THE expedition of University of Utah girls, who were the first to invade

Salt Lake Tribune
-May 18, 1920

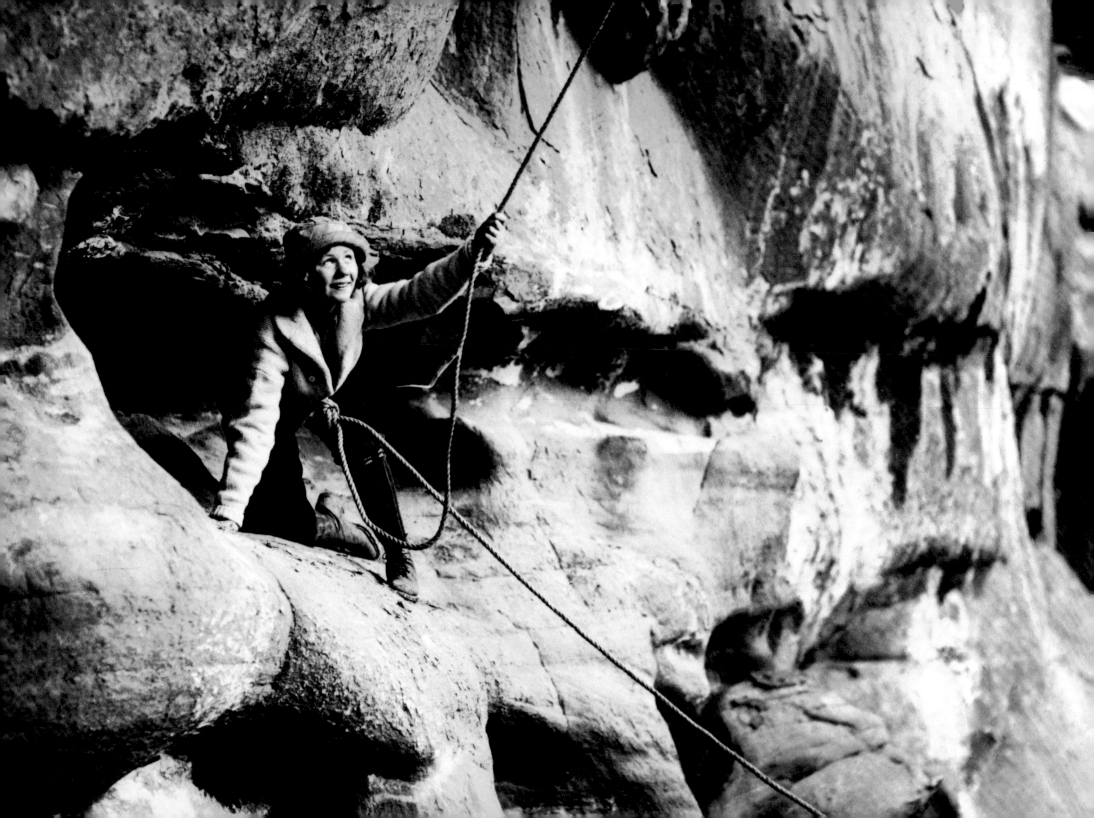

Left, Catherine Levering is trapped in an ancient cliff dwelling. Right, Al Pyper and Chauncey Parry help Catherine down from a lofty perch.

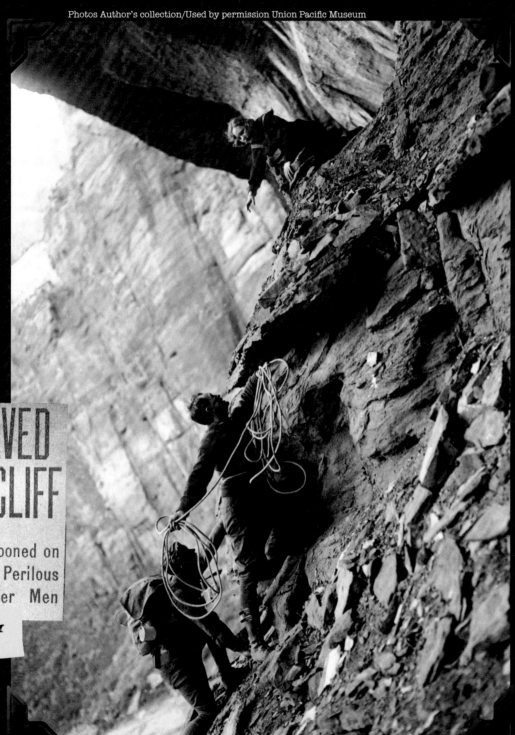

L. A. GIRL SAVED ON ROCKY CLIFF

Catherine Levering, Marooned on Crag, Rescued From Perilous Position by Newspaper Men

Los Angeles Examiner
-May 24, 1920

HIDE AND SEEK

As the party of university girls explored prehistoric cliff-side dwellings, Catherine Levering became "the heroine of an involuntary game of hide and seek."[1]

"Investigating a bit of ruined wall, she was lost to sight of the rest," the *Salt Lake Tribune* reported. "Thinking she had already climbed back down the cliff, [the party] made the descent to the trail and continued on up the canyon before her absence was discovered."[2]

According to the *Los Angeles Examiner*, Catherine spent "hours of patient toil, dangerous and hazardous to the most sure-footed," reaching a point close enough to the party to be seen. The *Examiner* claimed that "although they had not missed her, saw signals of distress as she was perched on a lonely crag. Waving her hat frantically, she brought help from Eyre Powell and Fred Coffey, Los Angeles newspapermen of the party.

"Ropes were secured and the rescue expedition started out to aid the young climber. She was picked off her crag and deposited on terra firma after she had done some rope climbing down the dizzy heights."[3] According to the *Salt Lake Tribune*, "she had been imprisoned in the antedeluvian apartment for some time."[4]

Before the excursion began, the *Los Angeles Evening Herald* ironically praised the selection of Catherine for climbing and posing on rocky cliffs based on her athletic capabilities.

"Catherine Levering, a beautiful young Los Angeles dancer, has been chosen as one of a feminine exploring expedition, which will invesigate both travelled and untravelled portions of Zion National Park," the *Herald* reported. "Miss Levering was chosen from among a countryful of beauties to join the party. She owes her invitation…to the fact that as an aid to her dancing here she has kept up keen interest in outdoor sports, and is as well prepared as any to scale cliffs and delve into prehistoric cliff dwellings in search of 'locations.' If a particularly beautiful picture is to be obtained from the top of a precipice, or by posing halfway up, her training as a dancer as well as an athlete will stand her in good stead."[5]

MEAL TIME

According to a National Railroad Administration brochure, meals served at Wylie Camp cost $1 each, the same price charged for a night in camp. For transportation to and from the park with lunch en route in each direction, two nights lodging, and five meals at Wylie Camp, the tourist could expect to pay $26.50. Of course the girls' expenses were paid in full by the railroad.[1]

Anna Widtsoe wrote about the fine food prepared by the Wylies. "We had the most wonderful chicken dinner," she said. "Chicken, gravy, potatoes, corn, egg a la biscuit, goosberry pie, coffee and hot biscuits."[2]

Occasionally the party of explorers ate lunch at camp, unless a trip back to home base was too far away. "At noon-time we perched ourselves on a cliff and enjoyed our midday lunch," Dora Montague observed.[3]

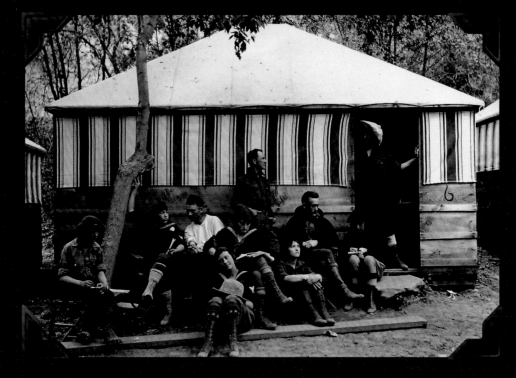

Photos Author's collection/Used by permission Union Pacific Museum

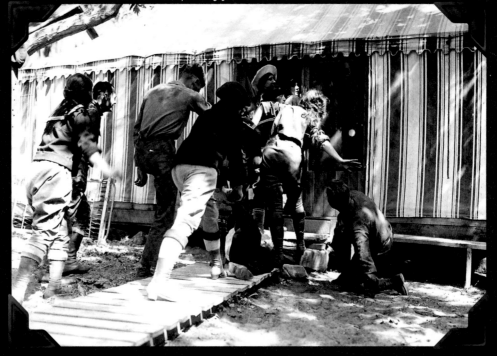

Left, "We just sat there waiting for the dinner gong to sound." Below left, "And then— 'everyone for himself'—for we were a hungry crew." Opposite, "After the scramble we were a quiet lot, awaiting our turn to be served."
— Dora Montague

Above, Clara Sample rings the dinner bell.

Zion Canyon
WYLIE WAY CAMP

Lund to Zion National Monument and return, including 7 meals, two lodgings at Wylie Camp and transportation both ways,	$26.50
Cedar City to Wylie Camp and return, transportation, 5 meals and 2 lodgings	21.50
Rates for persons with own cars per day	4.00
Saddle horses for hire, per day	3.00

W. W. WYLIE

Iron County Record
-July 4, 1919

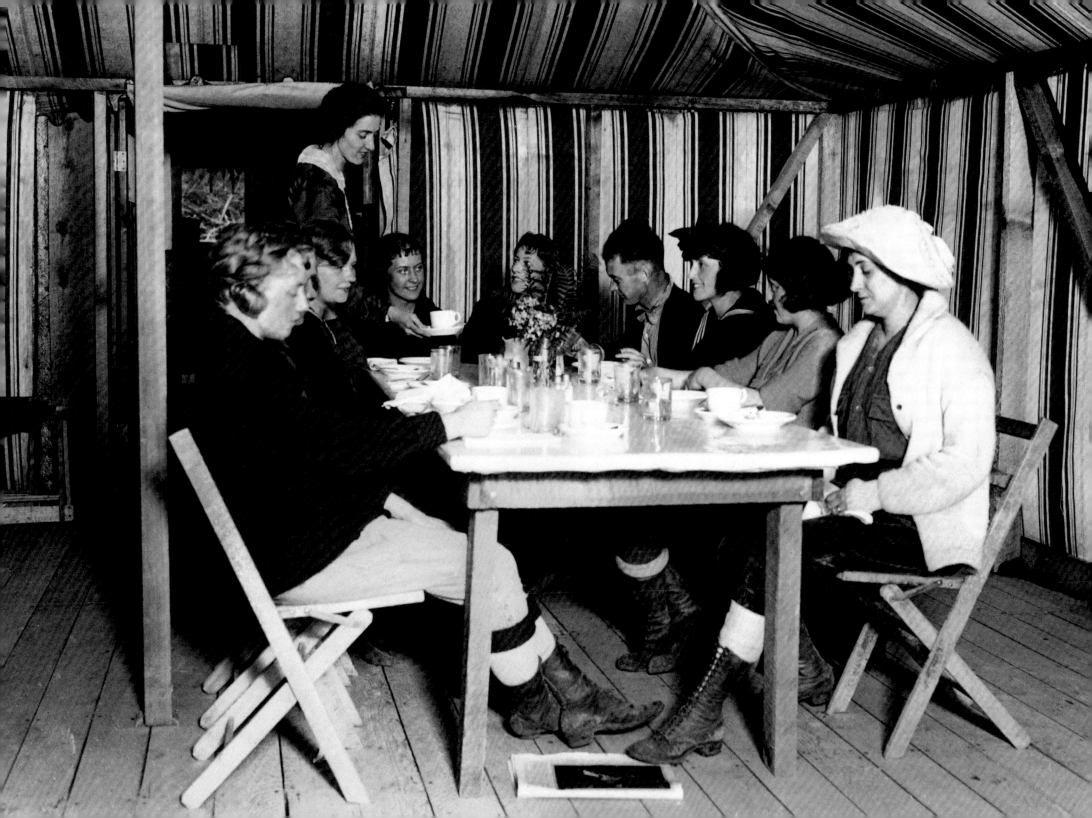

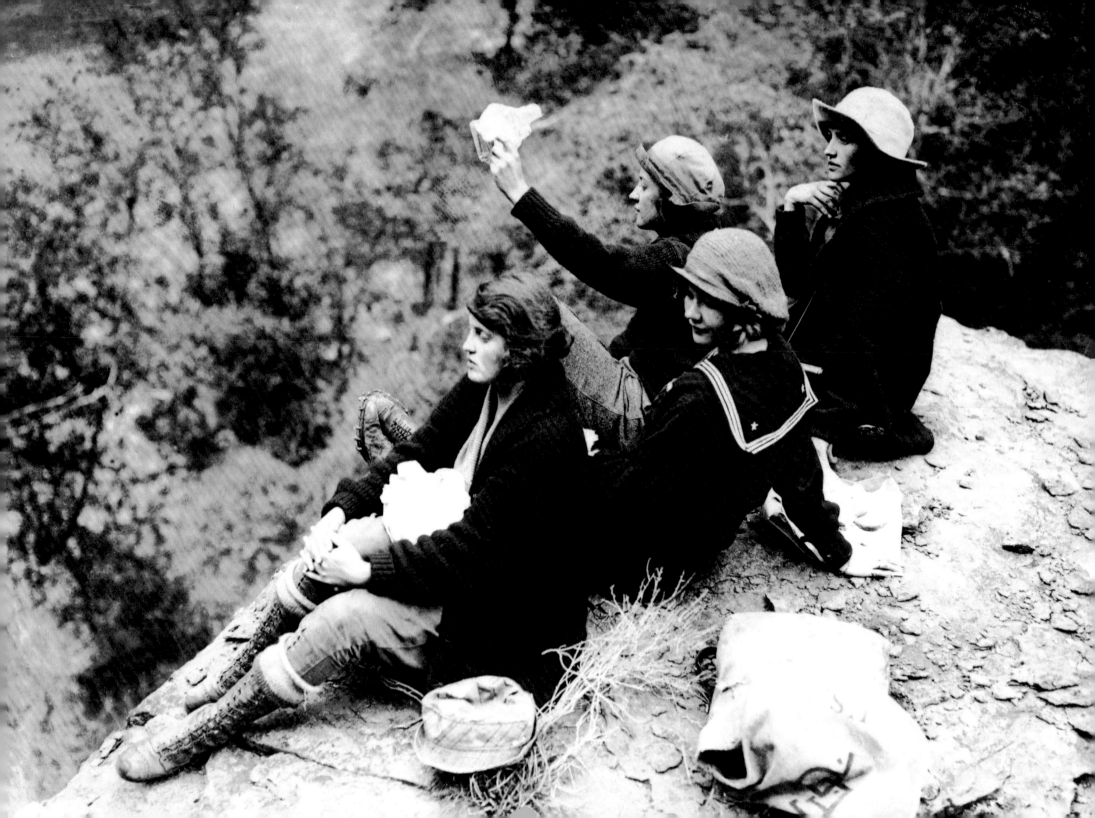

Los Angeles Sunday Times
-July 25, 1920

Opposite and right, Nell Creer, Catherine Levering, Mildred Gerrard and Dora Montague stop for lunch on the trail.

CAMPY CAPERS

Anna Widtsoe and her cohorts plotted revenge after falling victim to a prank played by the men. Anna and Nell switched tents with Dora Tuesday night to spring a trap on them. "We were armed with pitchers of cold water ready for the fellows, but they didn't come. Joke on us," Anna said.

Not satisfied with Tuesday evening's lack of success, the girls resumed their shenanigans while relaxing at camp the next day. "In the afternoon we had a scramble for Mr. Powell's cigars. He couldn't get along without them," Anna recalled. She tried to liberate the stogie during dinner with no success.

When Eyre Powell was finished eating, however, he was craving an after-dinner smoke. "He said aw ah! and pulled out this cigar," Anna quipped. "Quick as a flash I grabbed it and gave it to Melba who took it and hid it. He didn't know what to do for a minute then again as quick as a flash he took a spoon full of whipped cream from our jello and threw it in my face. Rough? Oh no. I jumped and started to run after him."

There were visitors in camp that night "and they all saw me," Anna said. "I cleaned up soon tho'." Perhaps embarrassed by Anna's antics, Chauncey Parry and Eyre Powell took her to Springdale.

The next evening, Anna said that she and Melba spent the night out. "I was simply crazy. Combed my hair straight back, put dirt on my face and wrestled with Fred. Really wild. Then covered poor tired Mr. Powell with sand. That was a mean dirty trick. Well, then Melba and I rushed into Chance's tent and pulled the mattress off both beds (Marv's too.) Of course there was yelling, and screaming," Anna remembered.

"The natural outcome was [for] the boys to grab us and put us in the tub, clothes and all. I was squeezing water out for an hour after. Mr. Powell was sore at me because of the sand and at the crew for disturbing the peace so late at night."

Although the men retaliated by dumping Anna in the tub, nature finally claimed the ultimate revenge. "Friday we awoke from sound slumbers with the warning bell and raining pitchforks," Anna said.

Her already wet clothes were now soaked by the early morning downpour. "I didn't have any other [clothes] and scouting around I got a brassiere, bloomers of Nell's, socks of Mr. Powell's, bedroom slippers of Mrs. Pete's, shirt and skirt of Melba's," she said. "My other clothes I hung by the stove to dry." Anna didn't speak of any additional pranks.[1]

"Good Night" at Camp Wylie. Two Pretty Hikers Prepare to Hit the Hay After a Strenuous Day.

Los Angeles Sunday Times
-July 25, 1920

Melba Dunyon and Dora Montague.

Right and far right, Melba Dunyon is ready to turn in for the night.

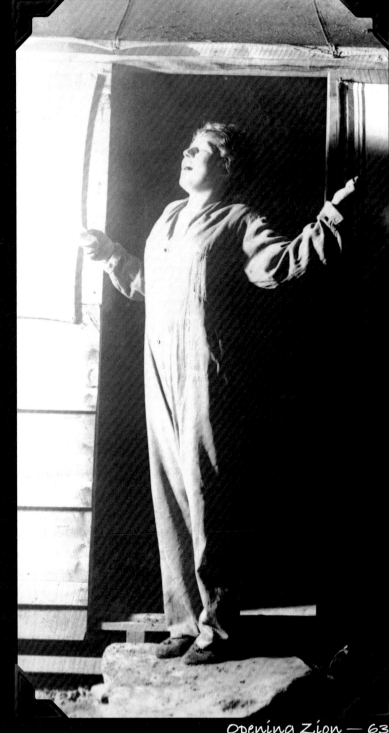

Photos Author's collection/Used by permission Union Pacific Museum

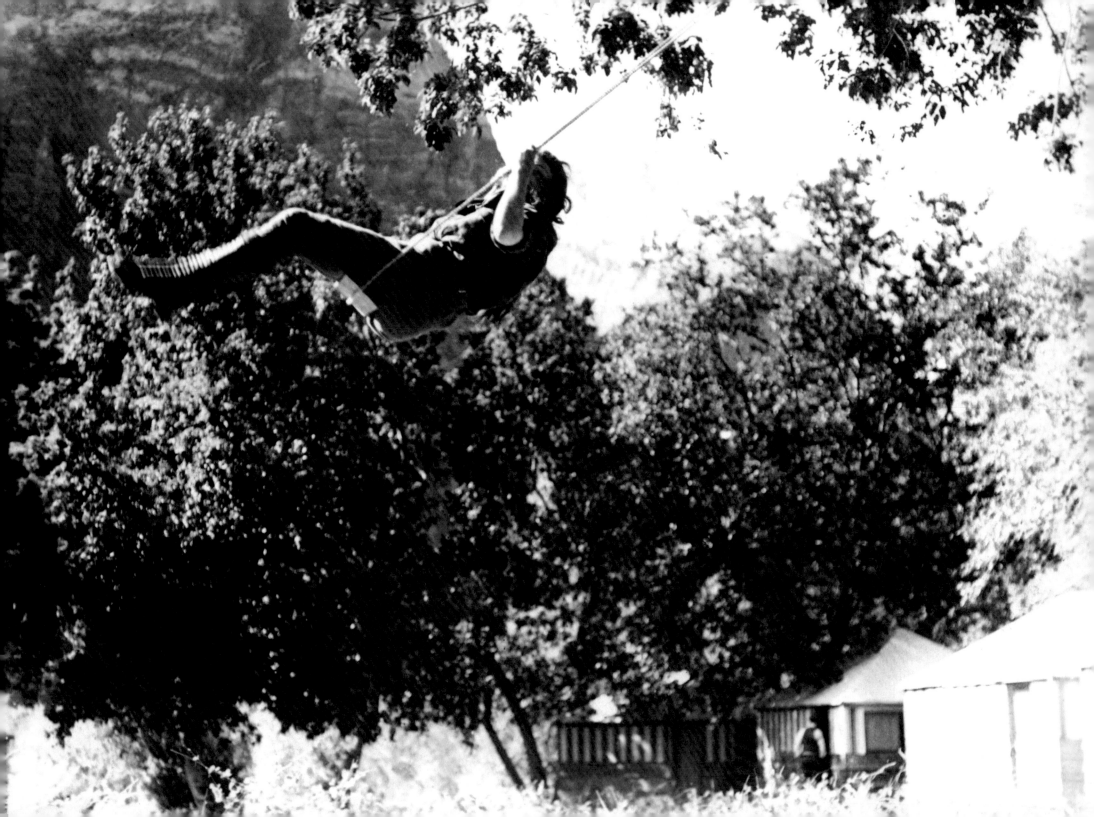

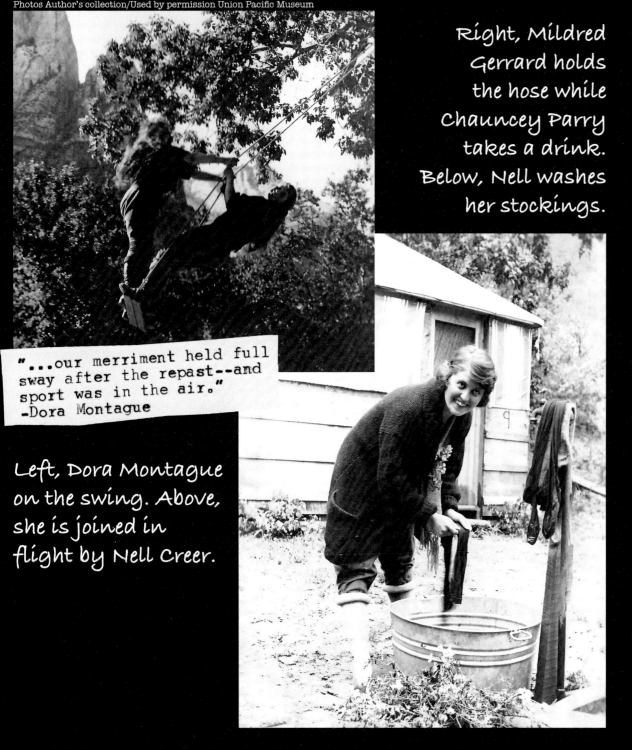

Right, Mildred Gerrard holds the hose while Chauncey Parry takes a drink. Below, Nell washes her stockings.

"...our merriment held full sway after the repast--and sport was in the air."
-Dora Montague

Left, Dora Montague on the swing. Above, she is joined in flight by Nell Creer.

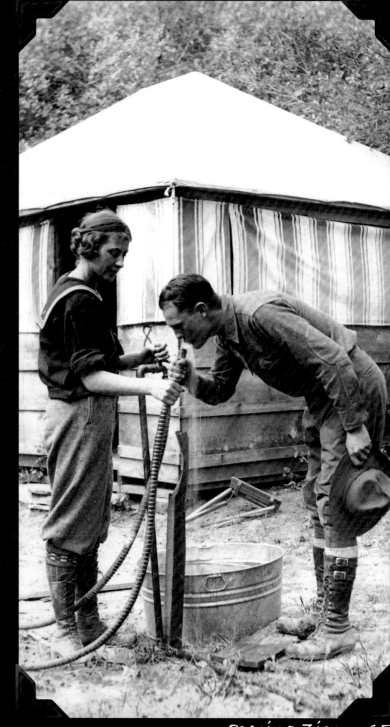

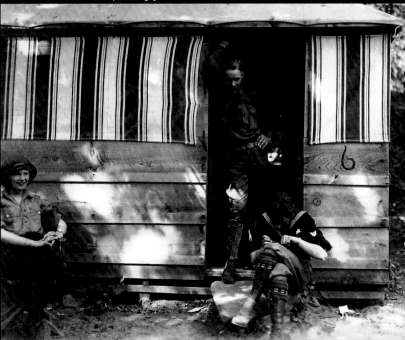

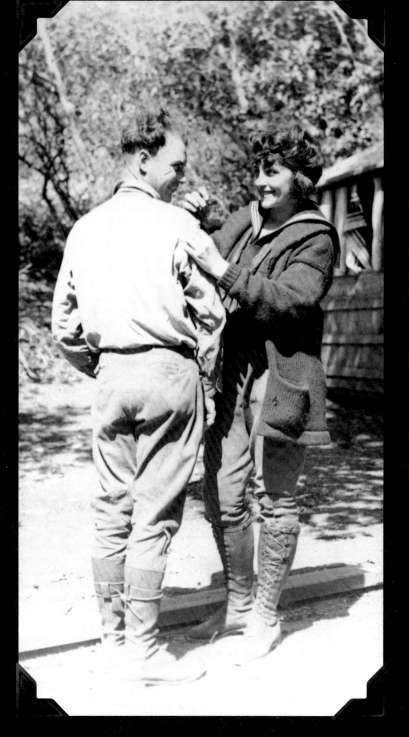

Top left, Nell Creer writes a letter. Below left, Al Pyper watches Mildred Gerrard give herself a much-needed manicure. Left, Dora Montague mends Fred Coffey's torn shirt. Right, Melba Dunyon, Mildred Gerrard (on the typewriter), Nell Creer, Dora Montague, and Anna Widtsoe write and rest at camp.

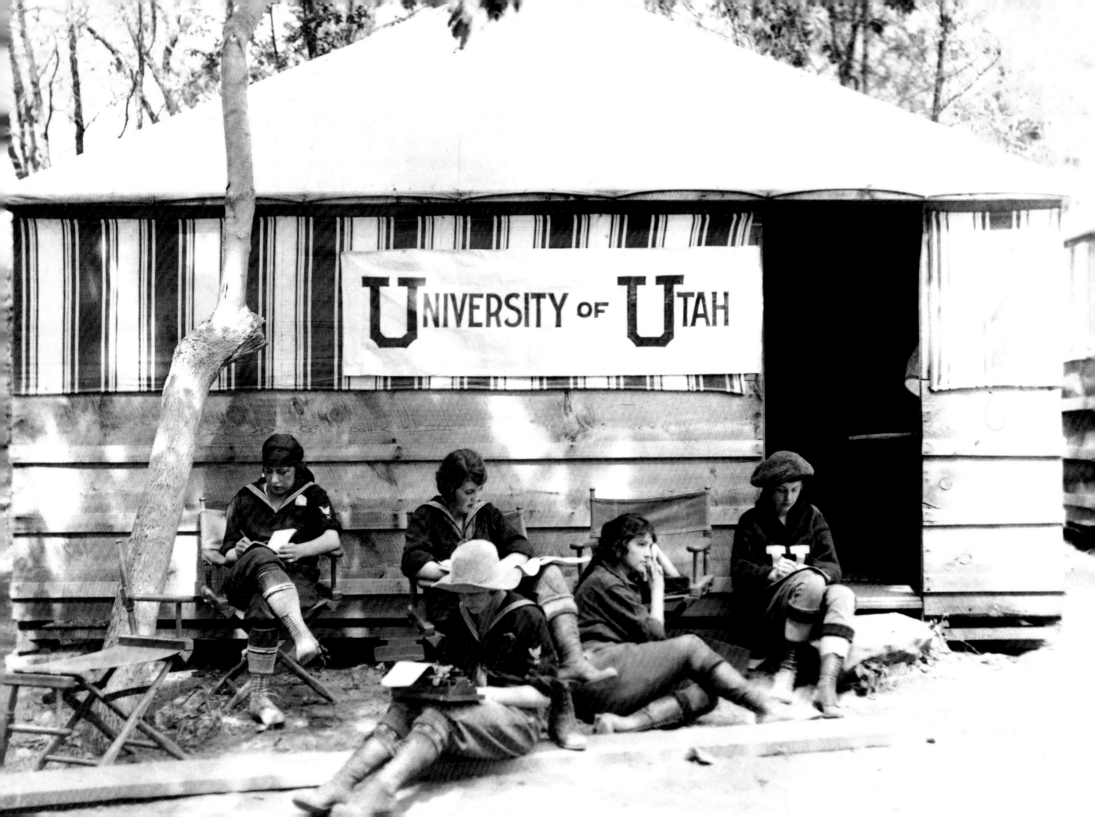

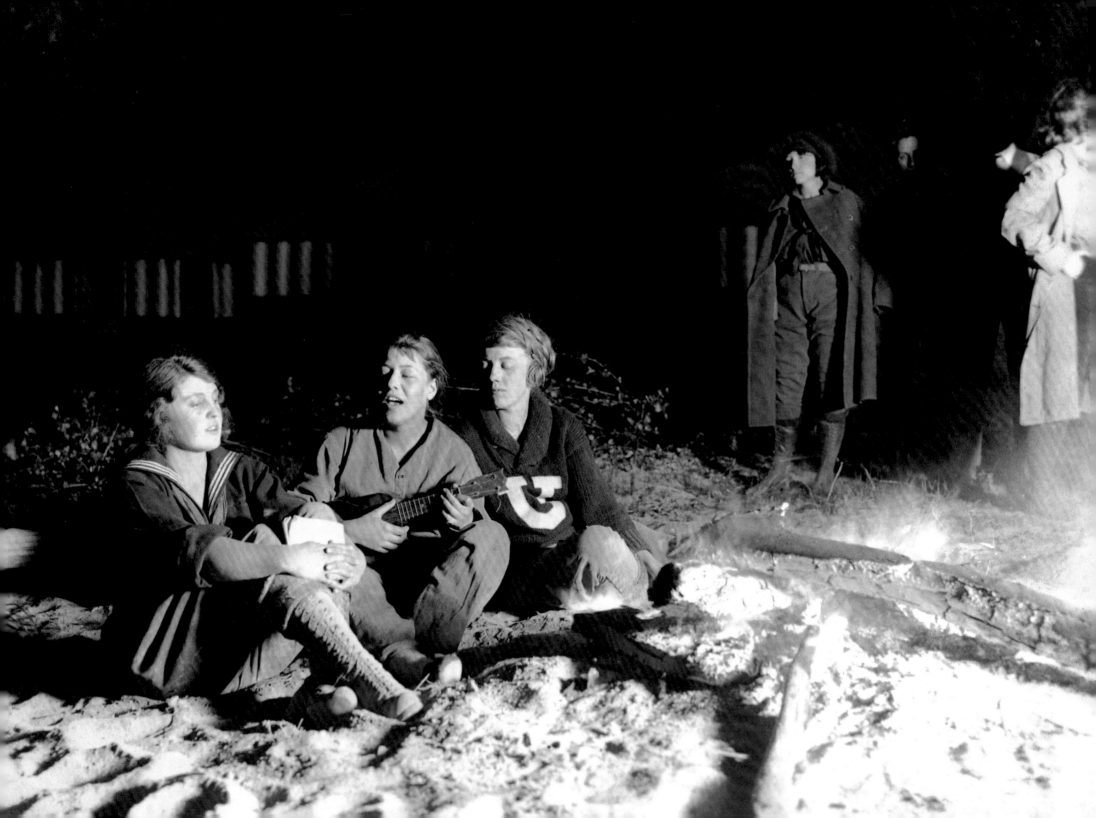

Opposite, Nell Creer, Melba Dunyon, and Anna Widtsoe sing campfire songs as Dora considers joining the lady crooners. Top left, Chauncey Parry tells bear stories. Below left, Nell Creer.

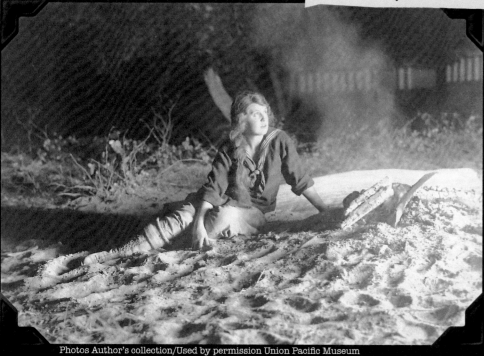

Chauncy Perry Telling a Good Story to Miss Catherine Levering of Los Angeles and Her Chum, Miss Mildred Gerrard of Salt Lake.

Los Angeles Sunday Times -July 25, 1920

AROUND THE CAMPFIRE

Most nights, as the sun set over the jagged cliffs of Zion National Park, the congenial campers gathered around a bonfire to sing. Among the songs echoing off the canyon walls was one the lady crooners composed themselves called "A Cheerful Family":

Gee but we're a cheerful crew, our lines blithe and gay.
Anne is on the warpath all day long.
Nell she says no foolin and the rest they have a way
of filling brother Powell's life with song
Tra-la-la
Fred he plays he's a wildcat and scares Dora into fits
and makes a first class maniac of me
Mildred's the candy maker Cathy's shoulder shaker
Gee but we're a hard-boiled family.
Same 1&2 lines (above)
We'll say we need a chaperone along — her moniker is Peterson
but since we've been away we've called her nipper in our jokes and song
Tra-la-la
If we try to fuss with Mary she nips us in the bud
competition squelches even me
you simply cannot make her a lady undertaker
Gee but we're a hard-boiled family.[1]

Melba Dunyon brought her ukulele along to accompany the crew. The fact that all the girls are mentioned by name in the song except for Melba leads one to believe that she wrote the lyrics.

On the last night the university girls spent around the campfire, Catherine Levering added her talents to the evening program. "Miss Catherine Levering of Los Angeles, who accompanied the party…gave several dances as a part of the campfire celebration staged at the Wylie camp," the *Salt Lake Herald* reported.[2]

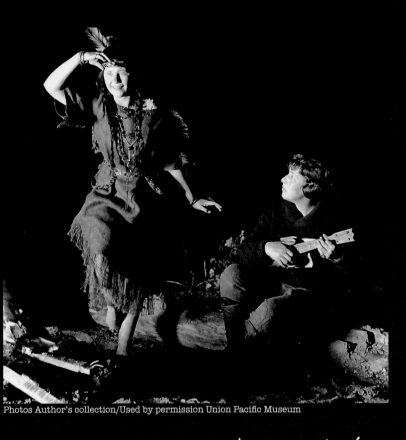

Above, Catherine Levering dances while Melba Dunyon plays the ukulele. Right, Catherine performs an "Indian study."

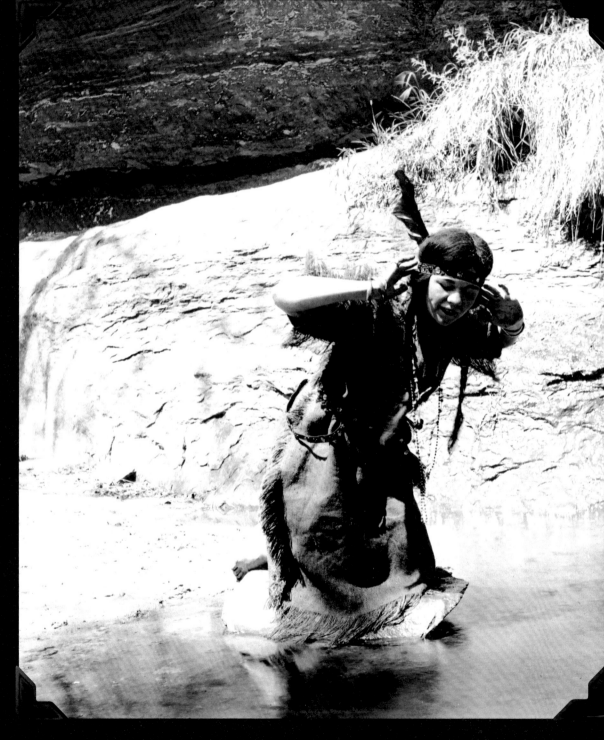

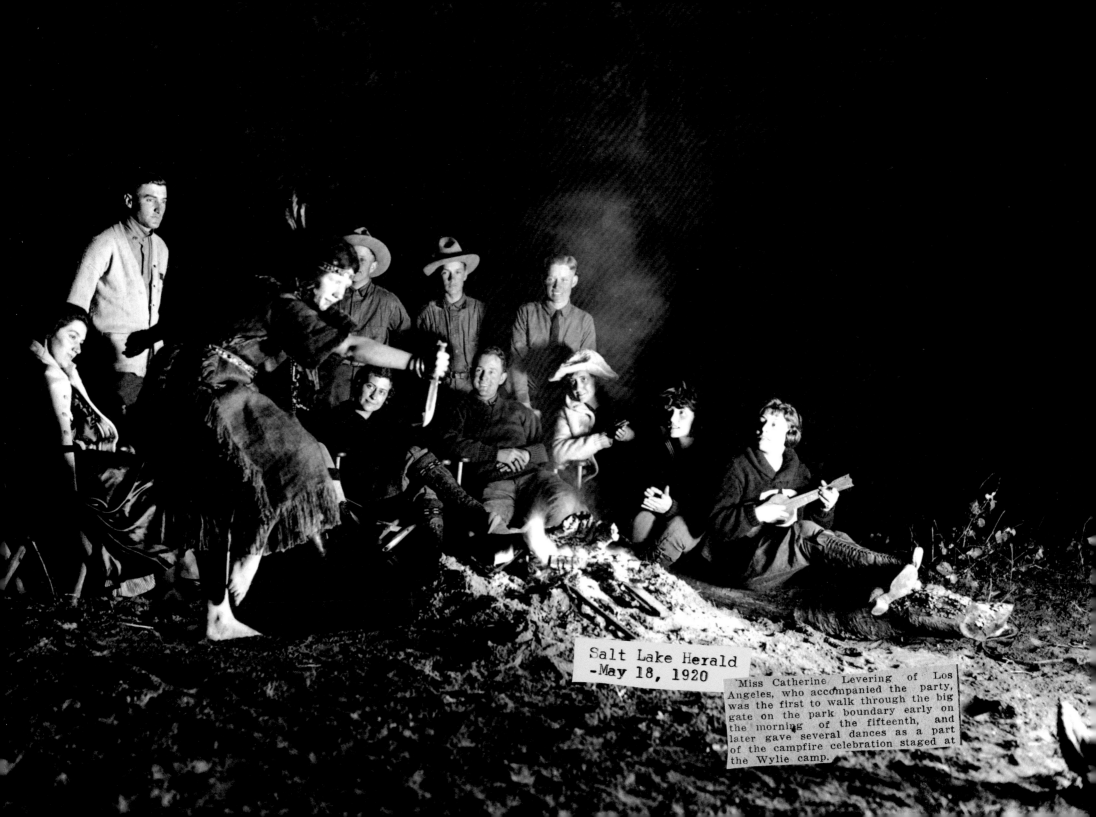

Salt Lake Herald
-May 18, 1920

Miss Catherine Levering of Los
Angeles, who accompanied the party,
was the first to walk through the big
gate on the park boundary early on
the morning of the fifteenth, and
later gave several dances as a part
of the campfire celebration staged at
the Wylie camp.

Very truly yours,

Stephen T Mather

Stephen T. Mather
National Park Service
Historic Photograph Collection,
Harpers Ferry Center,
photographer, Albright.

John B. Fairbanks, *The Great White Throne*, 1919. Oil on canvas, 36 1/8" x 24 1/8." Springville Museum of Art 1999.030, reprinted by permission.

Far left, Lafayette Hanchett, Salt Lake City businessman, was interested in the development of southern Utah. Left, 1919 painting of The Great White Throne by Fairbanks. Opposite, Nell Creer watches as John B. Fairbanks paints Angels Landing.

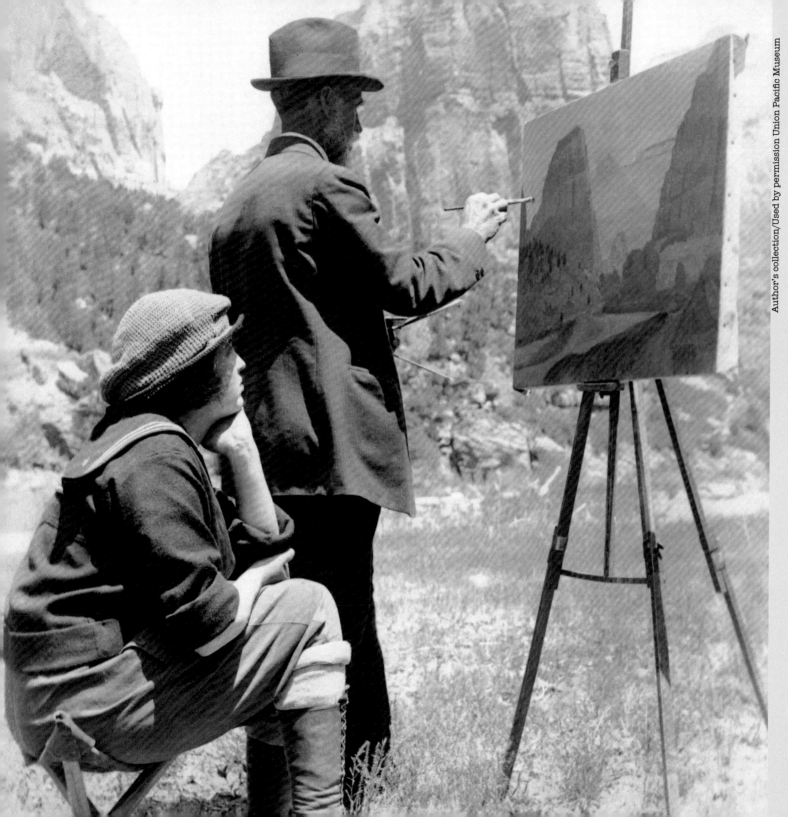

DISTINGUISHED VISITORS

The party of female tourists were not the only visitors to Zion National Park in the week before its official opening. John B. Fairbanks frequently wandered into the canyon to paint. Fairbanks was a well-known artist who taught at the Brigham Young Academy in Provo, Utah. He was one of four artists The Church of Jesus Christ of Latter-day Saints sent on an "art mission" to study at the Académie Julian in Paris in 1890.

Fairbanks frequently traveled around the Southwest. He visited Mexico, Central America, and South America as an artist and photographer. He is best known for his harvest scenes and for paintings of Zion National Park, where he spent four summers. While in the park, the university girls met John Fairbanks, who was painting the splendid scenery he has since become famous for.[1]

Anna Widtsoe wrote about additional visitors on Wednesday evening. "We had company in camp; Mr. John Dern, Mr. Halloran, Mr. Hanchett and one more."[2] John Dern, William Halloran, Lafayette Hanchett, and Eugene Giles visited Utah's "Dixieland" to inspect operations at the Dixie Power Company. The four businessmen held interests in the electric company.

"All of the gentlemen predicted a big future for Iron and Washington counties," the *Washington County News* reported. "They say the resources are immense and practically untouched."[3] Hanchett was deeply interested in the development of southern Utah, which included promoting Zion National Park as a tourist destination. In March 1920, Stephen T. Mather, director of the National Park Service in Washington D.C., sent Hanchett a gift. "Knowing of your interest in our national parks," Mather wrote to Hanchett, "I am pleased to send you a specially bound copy of my last annual report."[4]

Anna mentioned that "some salesman from the city" accompanied the four businessmen to the park. Months later, the *Washington County News* reported that Stephen T. Mather had visited Zion National Park with Lafayette Hanchett.[5] A *Deseret Evening News* article placed Mather in Salt Lake City on Sunday, May 16, the day before the university girls returned home.[6] The "salesman from the city" Anna met at Wylie camp appears to have been the national park director who would dedicate Zion four months later.

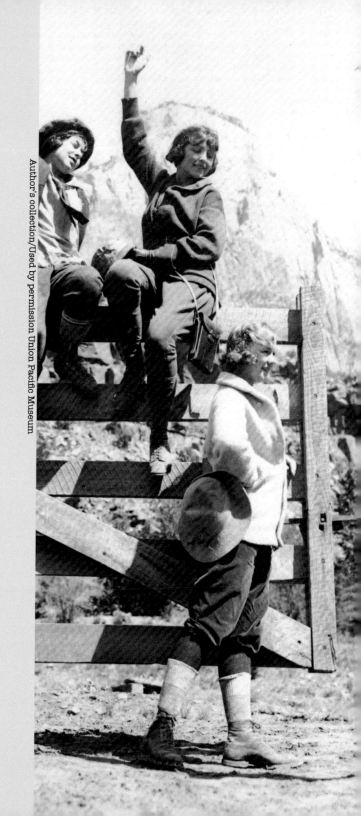

PART 3:
OPENING THE
GATE

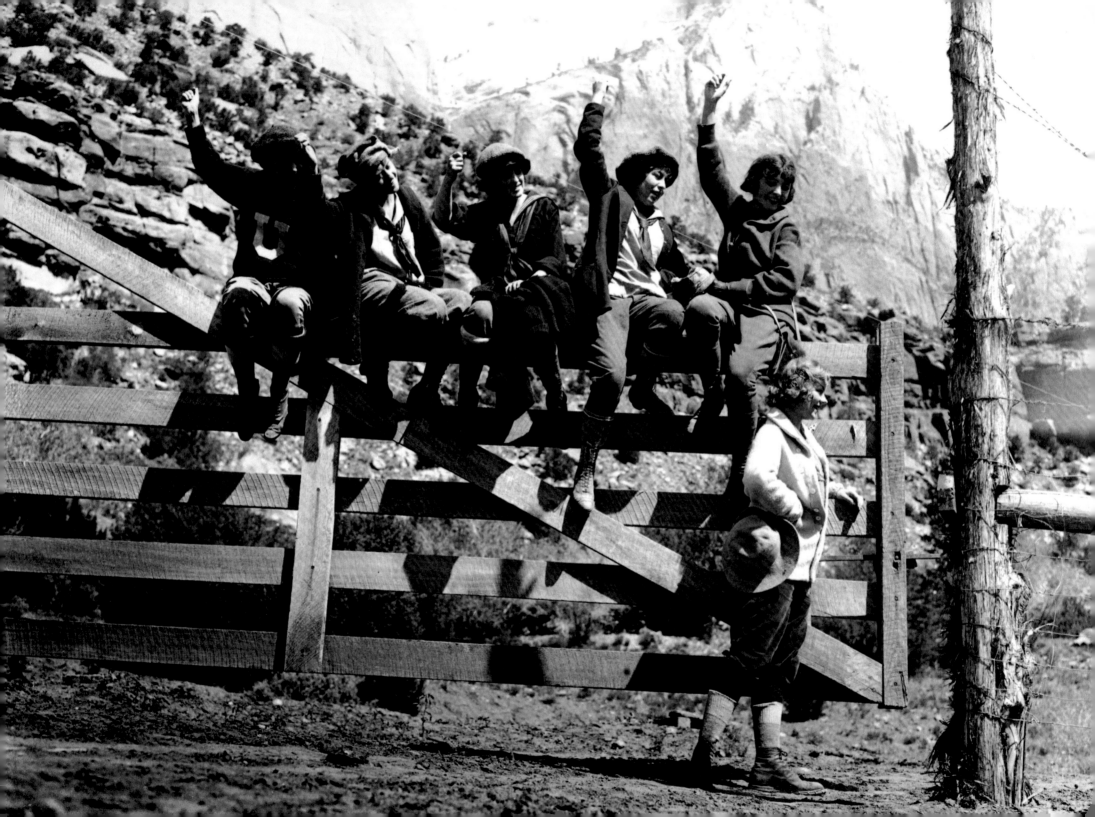

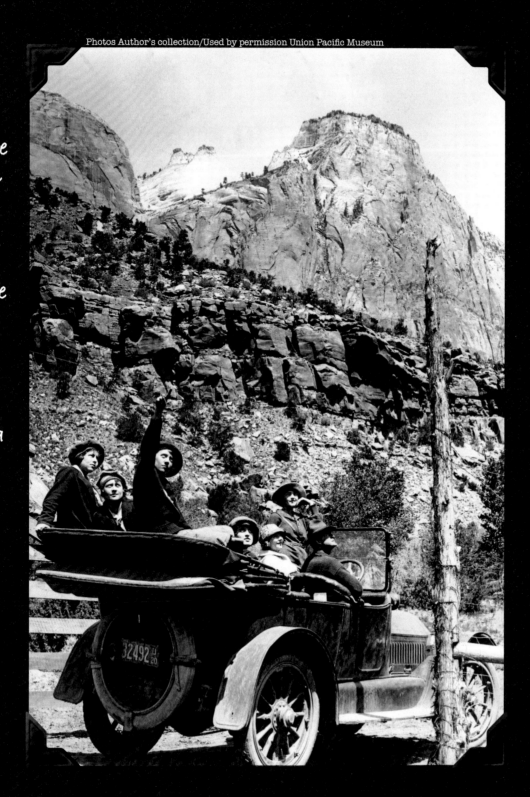

_eft, Catherine _evering's golden hair bounced in the morning breeze as she swung open the gate to Zion National Park on May 15, 1920. Perched atop the gate are, left to right, Anna Widtsoe, Mildred Gerrard, Nell Creer, Melba Dunyon, and Dora Montague. Right, having opened the gate the six girls enter the park as passengers in Chauncey Parry's auto stage.

OPENING DAY

With their wonderful week in the canyon drawing to a close, the party of university girls had one last important task to perform. On Saturday, May 15, 1920, they were granted the extraordinary privilege of opening Zion National Park to the world.

Under the headline "Zion Beckons to Vacationists: Park Open Without Ceremony," the *Salt Lake Herald* described the opening of Utah's first national park. "There has been a lot of pomp and ceremony in the opening of many edifices and many other playgrounds of the people. There have been speech-makings and christenings and ceremonials of all sorts on many such occasions. But on the day on which Zion Canyon was ready for visitors it was all as different as the place itself is from anything else. There was no ceremony, and none was needed," the *Herald* said.

"At the park boundary there is a plain wooden gate which swings across the road. To one side of it is the brawling Virgin River, and above the multicolored towers and spires of the wonderland rise for hundreds of feet.

"Early in the morning of that day a party of girls trooped up the canyon road. They reached the gate and climbed upon it to rest. No tight skirts hindered them as they clambered for they were in knickerbockers of the most practical outing cut and they wore stout little hobnailed boots that they kicked against the boards as they gazed at the spectacle about them.

"Behind them came a straggler, a young girl whose golden curls whipped around her head in the morning breeze. She reached her companions, smiled up at them, fumbled a moment with the latch and then, swinging the gate open, girls and all, walked through, leaving it wide behind her."[1]

Anna Widtsoe, Dora Montague, Mildred Gerrard, Nell Creer, Melba Dunyon, and Catherine Levering, who had the privilege of officially opening the gate, would spend only one more night in Zion. After loading into Chauncey's car, the girls quietly left the park on Sunday morning, May 16, bound for the little railroad station in Lund.

Upon their arrival in Salt Lake City on Monday, the *Deseret Evening News* asked them how they enjoyed their trip. The female explorers replied that they had "the time of their lives."[2]

EXPANDING OPERATIONS

The train that carried the university girls back to Salt Lake City delivered two additional passengers from the Zion expedition, Eyre Powell and Fred Coffey. The railroad publicity agents, "who secured 19 dozen fine views of this now celebrated canyon," divulged their plans to publish the images "in their various syndicates."[1] The photos appeared not only in newspapers around the globe, but in promotional materials published by the railroad.

In addition to promoting travel to Zion, the railroad continued to expand accommodations in and around the park. As early as 1918, Salt Lake Route officials surveyed the possibilities of laying track to Cedar City to bring tourists even closer to the canyon.[2] On April 27, 1921, the Union Pacific bought out the remaining interests of the Salt Lake Route, bringing greater focus to expanding their operations.[3]

On April 2, 1923, "the first scraperful of earth was turned" to build the rail spur from Lund to Cedar City. Only 87 days passed before the completed track hosted its first tourist, U.S. President Warren G. Harding, who was on his way to see Zion National Park for himself.[4]

An increasing number of visitors to Zion convinced railroad officials that a first-class hotel in the park was also needed. In 1922 they began searching for the perfect spot to build. After reaching an agreement with the National Park Service, they began construction of the Zion Lodge, which would eventually replace William W. Wylie's camp.[5]

In March 1923, a Union Pacific subsidiary known as the Utah Parks Company was incorporated to manage railroad operations in Zion. A fleet of buses was purchased to provide transportation from Cedar City to the park and eventually to the Grand Canyon, Bryce Canyon, and Cedar Breaks.

Chauncey and Gronway Parry operated their automobile stage line for a year or so after the Zion Lodge ceremoniously opened on May 15, 1925, five years after the university girls' visit to the park.[6] The railroad bought them out and then retained their services as transportation superintendents for 17 more years.[7]

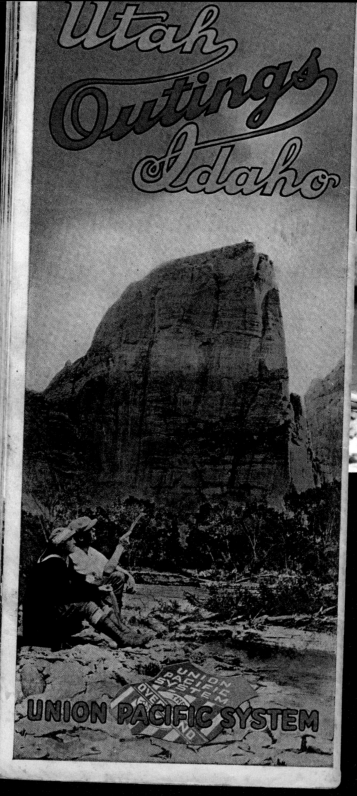

Left, Union Pacific Railroad brochure uses image, above, of Nell Creer and Fred Coffey to advertise travel to Zion by rail.

Right, Zion lodge opens in 1925 to accommodate rail tourists. Bottom, map shows rail spur from Lund to Cedar City.

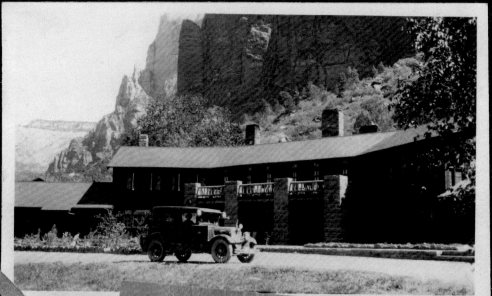

UNION PACIFIC SYSTEM

ZION-BRYCE
GRAND CANYON
NATIONAL PARKS
CEDAR BREAKS
KAIBAB FOREST

UNION PACIFIC SYSTEM
OVERLAND

UNION PACIFIC SYSTEM
OVERLAND

Form Z5 No. 7941

UTAH PARKS CO.

TOUR NO. 5
FIVE DAY ALL EXPENSE TICKET
FOR ONE PERSON
PRICE $89.50
INCLUDING MOTOR BUS TRANSPORTATION
AND
14 MEALS AND 4 LODGINGS

CEDAR CITY, UTAH
TO
ZION NATIONAL PARK
PIPE SPRING NATIONAL MONUMENT
KAIBAB FOREST
GRAND CANYON NATIONAL PARK
BRYCE CANYON NATIONAL MONUMENT
CEDAR BREAKS
TO
CEDAR CITY, UTAH

(Passenger)

Right, after incorporating the Utah Parks Company, the railroad purchased buses to take tourists into Zion, Bryce, and the Grand Canyon from Cedar City.

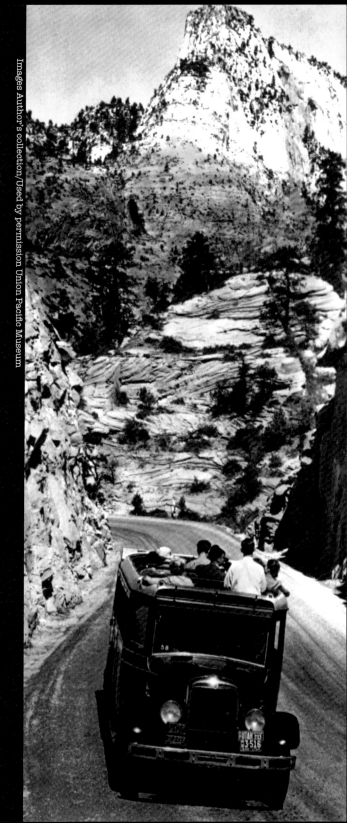

UTAH
···· THE UNIQUE

CHAMBER OF COMMERCE

GREAT
WHITE THRONE
ZION NAT'L PARK

Salt Lake City

"CENTER OF
SCENIC AMERICA"

CEDAR
UTAH
CITY

CEDAR BREAKS

ZION CANYON

BRYCE CANYON

BOULDER DAM

Commercial
organizations in
Salt Lake City
and southern
Utah broadcast the
wonders of Zion
National Park in
their advertising
literature.

VHITE THRONE · ZION NATIONAL

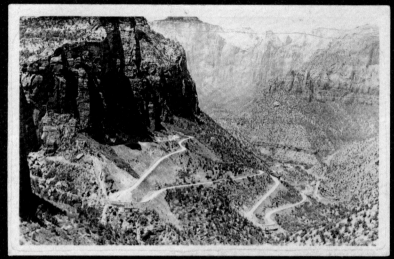

Left, greater
access to the park
was granted
when the Zion
tunnel and
switchbacks were
built. Below, the
road into Zion
circa 1923.

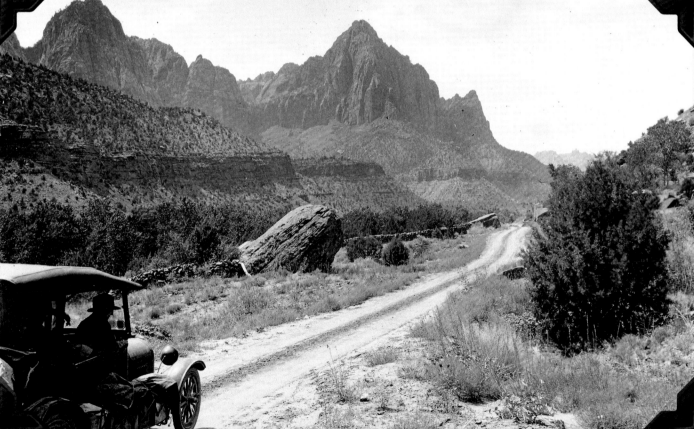

DEVELOPING ACCESS

Recognizing that tourism was good for Utah's economy, the Commercial Club in Salt Lake City actively advertised the scenery in southern Utah. Commercial organizations closer to the park also played an active role in broadcasting Zion's wonders to the world. Beautiful images of the Great White Throne and other stone temples appeared often in both Salt Lake and southern Utah advertising literature.

Lafayette Hanchett, who was a member of the Zion Park committee in the Salt Lake Commercial Club, took an active role in not only promoting travel to Zion, but also in developing access to the park. For example, Hanchett helped make arrangements to build the rail spur into Cedar City and improve the canyon's automobile roads.[1]

Wesley King and his wife, Wilhelmina, who were among Zion's earliest tourists, visited the national park again in June of 1920, less than one month after the university girls. When they originally made the trek to Zion in 1911, the trip consumed 18 days. In 1920, however, the entire trip took only seven days. Only four and one-half of those days were spent driving there and back to Salt Lake City in their own automobile.[2] Wesley King was also a member of the Salt Lake Commercial Club committee in charge of promoting development in Zion National Park.[3]

Government organizations such as the Utah State Road Commission cooperated with enthusiastic commercial interests by building better roads. Automobile admittance increased in 1925 when the canyon road was extended beyond Weeping Rock all the way to the Temple of Sinawava. By the early 1930s, the path-turned-boulevard was paved. Further access to the park was granted on July 4, 1930, when the Zion Tunnel and switchbacks were dedicated, connecting the park highway to its eastern entrance beyond the canyon rim.

Roads surrounding and leading to the park were also improved to bring travelers to the gates of Zion. The Arrowhead Trail, also called Zion Park Highway, became a part of the federal highway system in 1927 when it was renamed U.S. Highway 91.[4] Attention was often drawn to improving this road based on the merits of bringing tourists into the heart of scenic southern Utah.

With government support, railroad developments, commercial advertising, and improved roads in place, the stage was set. Zion National Park's cast of ancient stone characters awaited the flood of tourism that would follow.

THE FLOOD THAT FOLLOWED

A small crowd gathered to watch as the university girls opened Utah's first national park. "Zion National Park was informally opened for the season Saturday, at the Wylie Way camp...with a patronage of about 60 people," the *Deseret Evening News* reported.[1] This was a relatively small group compared to the large assembly that attended the formal dedication of the park four months later. According to park records, 857 people, who came in 257 automobiles, attended the ceremony.

Stephen T. Mather, director of the national park service, dedicated Zion on September 15, 1920, with these words:

"This day we shall long remember. Today is the christening day of a most wondrous child born of God and nature—a child of such ethereal beauty that man stands enthralled in her presence. Born but yesterday—the yesterday of nature when man was not, it yet remains for man this day to be thy godfather, to keep and cherish thee forever as one of the beauteous things of the earth and to christen thee—Zion National Park."

Among the dignitaries who participated in the service were Utah Senator Reed Smoot, former Utah Governor William Spry, Salt Lake City Mayor C. Clarence Nelsen, and Heber J. Grant, president of the Mormon Church. They spoke of Zion's past, pledged support for its development, and foretold its future, perhaps unaware of just how quickly interest in the new national park would grow.[2]

In the 1920 season, 3,692 visitors entered the park, a number that nearly doubled from the year before.[3] In 1930, 10 years after the girls visited, more than 55,000 people saw Zion, a number that reached 160,000 by 1940.[4]

Anna Widtsoe lived seventy more years after her first visit to Zion. Before she died in 1990, annual park visits surpassed 2 million people.[5]

When six young ladies opened Zion National Park, it was more than a literal beginning to the tourist season of 1920. Having flung the gate wide open in their informal ceremony, Anna and her intrepid female companions became the park's first official tourists, opening a world of wonder to unseen generations of visitors.

Images, Author's collection

Photo by John Clark

In 1930, annual visits to Zion National Park reached 55,000, a number that topped 160,000 by 1940. Today, nearly 3 million people a year see Zion.

UTAH
Road Map
1940

Utah Department of Transportation

FOR FREE DISTRIBUTION

ZION NATIONAL PARK
1930

ANNA GAARDEN WIDTSOE
1899-1990

Anna Widtsoe was born on Easter Sunday amidst "the ringing of many bells" in the quaint little town of Göttingen, Germany. Her parents were on an educational tour of Europe that included study at the local university. Before Anna's second birthday, she saw Berlin, Zürich, and London. In July 1900, the Widtsoe family returned to Utah.[1]

After her trip to Zion National Park, Anna went back to the University of Utah in the fall of 1920. She proudly voted in the first general election held after the 19th Amendment granted voting rights to women.[2]

Always the socialite, she dated often, hoping to settle down. By the summer of 1921, however, her prospects were few. Feeling restless, she decided to take on a new challenge.

In October 1921, Anna Widtsoe left home to serve a mission for The Church of Jesus Christ of Latter-day Saints. She was called to the Southern States mission that included Florida, Georgia, North and South Carolina, Virginia, Alabama, Mississippi, Tennessee, Kentucky, and Ohio.

After coming home in 1923, Anna decided to finish her education. She graduated from Brigham Young University in Provo, Utah, with a Bachelor of Science degree in 1924.[3]

Anna's desire to settle down and have a family were realized when she married Lewis Wallace in 1926.[4] The couple had three children, John, Joanne, and Margaret. Sadly, her marriage didn't last. The couple divorced in 1933.[5] Anna's daughter Joanne said, however, that her mother and father remained friends.

Anna Widtsoe never remarried. Instead she went back to school and eventually became a librarian. For many years, she managed the Widtsoe family collection of books held by the University of Utah.[6]

As a librarian, Anna recognized the importance of saving family documents and photographs. She donated her personal collection to the Utah State Historical Society; the preservation of that material aided significantly in the production of this book.

Anna's 1920 trip to Zion National Park taught her to pack light. When she was interviewed in 1973 about her excursion, she said she learned to carry only a tote bag with a change of clothes, a book, knitting, and a deck of cards. "If I don't want company I read; if I want conversation I knit; if I want company I play solitaire."[7]

BIOGRAPHIES

Right, Anna with her son John and "Auntie Gaarden." Below, Anna poses with soldiers circa 1940s. Below right, Anna in North Carolina on a mission.

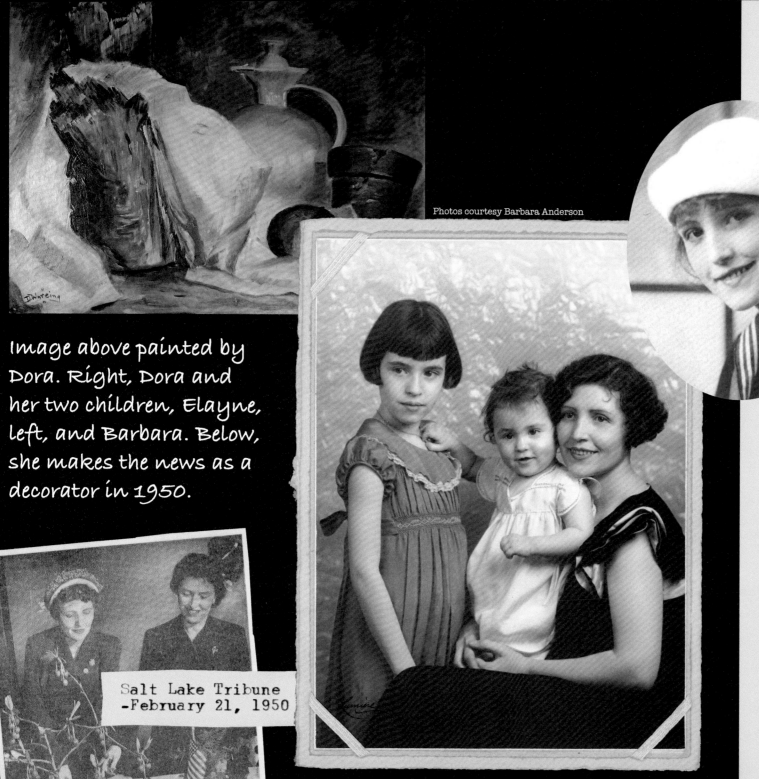

Photos courtesy Barbara Anderson

ISADORA (DORA) MONTAGUE
1899-1986

Dora grew up in the small town of Payson, Utah. She attended LDS Business College before enrolling at the University of Utah.[1] She studied art at the U and took classes from well-known Utah artists such as Lee Green Richards at the famous Art Barn in Salt Lake City.[2]

Dora married George C. Wareing in 1924 and soon after left Utah while George pursued his career. They moved often, living in California, Ohio, and Michigan. They had two children, Elayne and Barbara.

In 1939, the Wareing family moved back to Salt Lake, where George opened an insurance office.[3] Even though Dora retired from her daredevil ways to some degree after marriage, she was still unpredictable if she got a "bee in her bonnet." Dora really wanted a home of her own after moving back to Salt Lake City, but George kept putting her off. "She waited till he left town for a business trip," Dora's daughter Barbara remembered, "then she went and bought a house, and when he came home [Dora told him] 'oh by the way, we're moving.'"

While her daughter Barbara was a student at the University of Utah, Dora also took some classes in pursuit of a degree. "I practically flunked my classes trying to keep her from flunking hers," Barbara said. "Biology was unreal to her, it was the dissection of frogs that got her." The girl who had no fear of heights disliked "creepy-crawly" things, including snakes. When the family would go camping, Dora stacked rocks around the tent, hoping to keep the slithering reptiles out.

Dora loved the outdoors. Her family often visited the national parks, including Zion, Grand Canyon, and Yellowstone. Sometimes, they visited Zion National Park as many as two or three times a year.

After George died in 1974, Dora moved to St. George, where she bought a condo. She found time there to pursue her love of painting.

Barbara lived in nearby Cedar City and frequently took her mother to Zion, where they would sit in the lodge and reminisce. Not many years before she died, Dora heard that a well-known rock climber was planning to scale a wall in Zion. She had Barbara take her to the canyon to watch him climb the cracks from the river to the rim. The woman who years before was suspended over a Zion chasm got "a big charge out of watching that."[4]

Image above painted by Dora. Right, Dora and her two children, Elayne, left, and Barbara. Below, she makes the news as a decorator in 1950.

Salt Lake Tribune
-February 21, 1950

ELIZABETH MILDRED GERRARD
1899-1993

Mildred Gerrard was born in Taylorsville, Utah, where she lived in a large two-story red brick house. Her family moved to Salt Lake City in 1918. She spent one year at the University of California in Berkeley and three years at the University of Utah. Mildred was actively involved in school. She was a member of the Chi Omega sorority and Theta Alpha Phi, a national dramatics fraternity. Her love for theater landed her a part in a university play titled "Charm School."

In 1922, Mildred joined the staff of the *Utonian*. There she fell in love with the editor of the yearbook, Elmer C. Jenkins. She graduated with a Bachelor of Science degree in 1923, majoring in speech. Later that year, she married Elmer. John A. Widtsoe, Anna's father, performed the ceremony. While living in Salt Lake City, the happy couple had two children, Edward and Mary Lou.

The family moved to Hawaii in 1943, shortly after the outbreak of World War II in the Pacific.[1] Mildred volunteered at Tripler Army Hospital, which was built in response to the attack on Pearl Harbor in 1941.[2] She served as a "Gray Lady" for the American Red Cross, a term that referred to volunteers who provided nonmedical personal services for sick, injured, and disabled patients.[3] She also volunteered at Queen's Hospital in Honolulu.

When she wasn't busy volunteering, Mildred was a professor of speech at the University of Hawaii, a position she held for 10 years. She also taught theology and literature in both Honolulu and Salt Lake City.[4]

The world saw a great deal of Mildred and Elmer. While living in Hawaii, they crossed the Pacific Ocean 26 times. They honeymooned in Europe for two weeks and returned again in 1959. They also visited New Zealand, Australia, and the Orient.[5]

The Jenkins moved back to Salt Lake City in 1965, where Elmer continued to work for the American Savings and Loan Association. He also spent 10 years as a host at the Visitors' Center on Temple Square.[6]

Always a lady, Mildred's daughter Mary Lou said that her mother's trip to Zion was probably the only time she ever wore pants.

Mildred was the last of the six girls to pass away. On the day she died, Elmer lapsed into a coma, joining her in death only 48 hours later.[7]

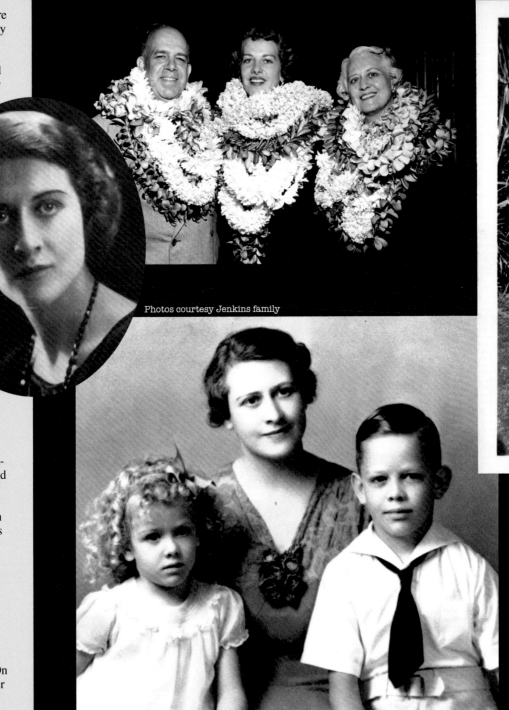

Photos courtesy Jenkins family

Top left, Elmer, Mary Lou, and Mildred in Hawaii circa 1950s. Left, Mildred and her children, Mary Lou and "Jerry," 1933. Above, Mildred as a "Gray Lady" during World War II.

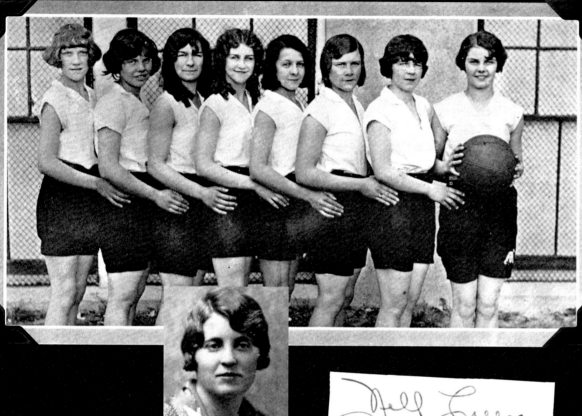

Top, Murray High School girl's basketball team in 1930. Nell was their coach. Left, Nell washes her stockings at Wylie Camp in Zion National Park.

AGNESS ELLEN (NELL) CREER
1899-1979

Nell Creer was born in Lakeshore, Utah, near Spanish Fork. She graduated from the University of Utah in 1922, where she received a Bachelor of Arts degree. At the time she was said "to have been the first girl from Spanish Fork to have earned a college degree."

She continued her studies after graduation, taking adult education courses in child training, photography, millinery, cooking, real estate, literature, and bible study.

Nell became a school teacher. She spent most of her short career teaching physical education at Murray High School.[1]

"She was a very likeable person," Merle Hobbs Casper said of her former instructor. "She was very full of life and enthusiastic...we all just thought she was just great." Nell's students liked her so much they intentionally wrote left-handed to emulate their teacher. "Irma Sanders Watts was my penmanship teacher and she was so upset," Merle remembered, "cause we were all starting to write back handed. 'I wish you girls would write correctly,' " Merle said, quoting Mrs. Watts, "Just because some teacher writes this way!"

Merle was a member of a basketball team that Nell organized for the girls of Murray High. Female basketball was rare in Utah in the 1920s. When Nell could find another school that had a team, she would organize games with them. Sometimes the Murray High team would play against the University of Utah. The younger girls rarely beat the college team, but received plenty of good practice.[2]

Nell left teaching after marrying John Wallace Frame in 1930. She met her husband while in college, but Mr. Frame was too busy studying dentistry to settle down. Once established, though, the couple moved to Los Angeles, where they spent most of their lives together.

Nell continued to work with young people in California, organizing dances at the American Legion Hall during World War II to keep them from wandering the streets.

The Frames had two sons of their own, John Wallace Jr. and Milton. Milton was killed in a car accident in 1952, inspiring Nell to study genealogy. She wrote several books on her family's history, travelling the globe to gather the stories of her ancestors.[3]

CATHERINE ALICE LEVERING
1906-1989

An unmarked news clipping in her scrapbook called Catherine a "Denver Girl," the city where she was born.[1]

After her father died, she moved to Salt Lake City with her mother, Cordelia, in 1911.[2]

Catherine displayed exceptional musical talent. Her mother enrolled her in violin classes at the age of nine where she studied under professor George Skelton.[3] The young Catherine performed in several public recitals including one with the orchestra from Salt Lake City's Orpheum Theater.[4]

Catherine also studied dance under Miss Lucile Thurman, who was a former pupil of the Denishawn School. In 1919 Catherine performed a sword dance in a vaudeville variety show titled "Beauty Chorus."[5]

In June 1919 Catherine left Utah to attend the Denishawn School of Dancing and Related Arts in Los Angeles, California.[6] She excelled as a musician while attending several high-profile schools. She graduated from the Zoellner Conservatory of Music in Los Angeles before she was 17 years old. In 1923, Catherine studied with Leopold Auer, a famous Hungarian violinist, at the Chicago Conservatory of Music.[7] She also attended the Peabody Institute at Johns Hopkins University in Baltimore, Maryland.[8] Founded in 1857, the conservatory was the first academy of music established in the United States.[9] While still in her teens, Catherine ran her own school of music and dance in Los Angeles and filled several motion picture contracts.[10]

She moved to Reno, Nevada, and opened a music studio there in May 1931, but closed her studio after only a year.[11] She moved back to Salt Lake City in 1932, becoming the head of the violin department at the Modern School of Music.[12]

While in Salt Lake City, Catherine met Donald Bjelke. They married on May 29, 1933, in San Francisco.[13] The Bjelkes made their home in Oakland, California, and had two children, Donald and Cordelia.[14]

The couple later divorced, and Catherine married Jason Manzer in the late 1940s. That marriage ended in the early 1960s.[15]

Catherine was a member of the Oakland Symphony Orchestra for many years. She also continued to teach music in the San Francisco Bay Area, where she remained for the rest of her life.[16]

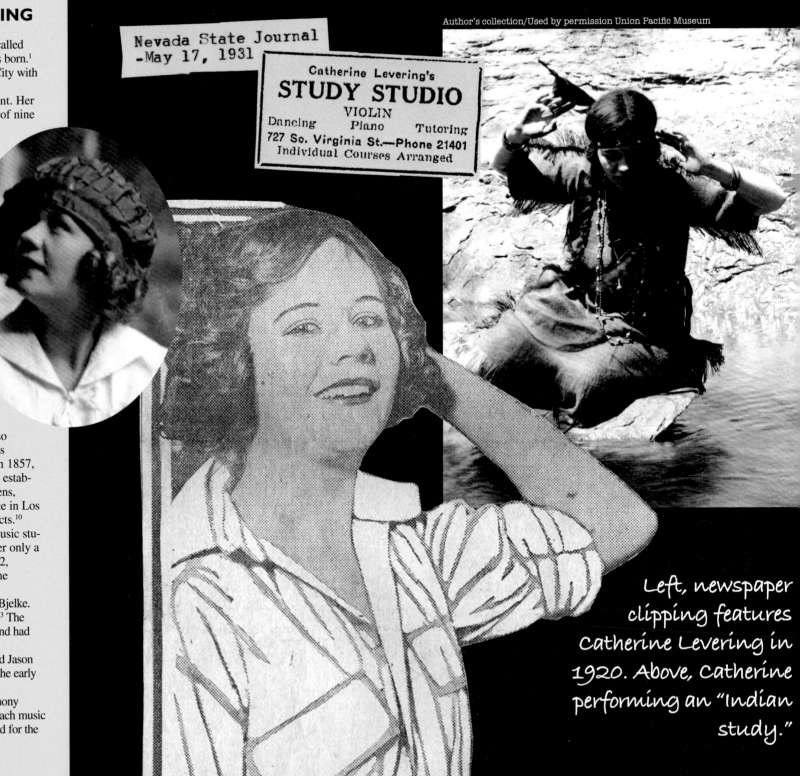

Nevada State Journal
—May 17, 1931

Catherine Levering's
STUDY STUDIO
VIOLIN
Dancing Piano Tutoring
727 So. Virginia St.—Phone 21401
Individual Courses Arranged

Left, newspaper clipping features Catherine Levering in 1920. Above, Catherine performing an "Indian study."

A Souvenir of
GOLDEN GATE INTERNATIONAL EXPOSITION
1939

No.S 699583

EXECUTIVE SECRETARY
PRESIDENT

Photo courtesy Barbara Anderson

Above, Melba Dunyon worked on Treasure Island during the 1939 San Francisco World's Fair. Right, Melba plays her ukulele for loose change. Below, she wears a Native American costume in Zion.

Photo courtesy Barbara Anderson

MELBA VICTORIA DUNYON
1900-1978

Melba Dunyon was born in Tooele, Utah, where her father taught school. The Dunyons moved to Salt Lake City in 1904.

Melba had a reputation, even at the young age of 13, for her skill as a cellist.[1] Melba was no stranger to stringed instruments, including the popular 1920s ukulele.

Under the title, "University Synonyms" in the 1921 *Utonian* yearbook, Melba's name appeared next to the word "enchantress." By 1923, Melba was attending the University of California at Berkeley. She transferred there when her family moved to the Bay Area. After the move, she met and married Earl Reed in 1923.[2] The couple made their home in North Berkeley and had two children.

The Reeds divorced in 1935, prompting Melba to seek employment. "My mother had various occupations thereafter," Melba's daughter, Jocelyn, said.

She worked for the Berkeley Women's City Club, the Athens Athletic Club in Oakland, California, and later did publicity writing for various organizations.

In 1939, she joined a host of people from the Bay Area who made the Golden Gate International Exposition in San Francisco a success. Melba spent her time at the 1939 World's Fair working on Treasure Island, built specifically for the occasion.

In the 1950s, Melba became a manufacturers' representative for several toy companies. She dealt with many of the product lines that were being imported from Europe.

Unfortunately Melba's busy schedule kept her from pursuing her beloved music. When Melba's father, Phares, died in 1939, her mother, Lois, came to live with them. Melba took care of her aging mother for the next 27 years until she died in 1966 at the age of 90.

Melba continued to work hard for the remainder of her life. She didn't leave the workforce until 1974 when she was 74 years old.

Her family doesn't know if she ever returned to Zion National Park after its official opening in the spring of 1920. Her daughter and two of her grandchildren, however, visited in the summer of 2009, proud to remember that Melba participated in Zion's opening nearly 90 years before.[3]

PART 1:
PROMOTING ZION

EMERGING FROM OBSCURITY

1. Angus M. Woodbury, *A History of Southern Utah and Its National Parks* (Springdale, Utah: Zion Natural History Association, 1950), 186.

2. Wesley E. King, "Traveling Beyond the Railroads in Southern Utah," *Salt Lake Tribune*, November 12, 1911, magazine section, 4.

3. Woodbury, *Southern Utah and Its National Parks*, 199.

4. *Report of the Director of the National Park Service 1919* (Washington: Government Printing Office, 1919), 260.

A GIRL IN LOVE

1. Anna G. Widtsoe, personal journal, July 1, 1919, Widtsoe Family Papers, 1866–1966, Utah State Historical Society, MSSB92, box 14 folder 2.

2. Ibid., July 7, 1919.

3. Ibid.

4. Ibid., July 26, 1919.

ACCOMMODATING TOURISTS

1. Janet B. Seegmiller, *Selling the Scenery: Chauncey and Gronway Parry and the Birth of Southern Utah's Tourism and Movie Industries* (paper presented at the Annual Utah State History Conference, Salt Lake City, Utah, September 2005), 3. Paper in author's possession.

2. John R. Signor, *The Los Angeles and Salt Lake Railroad Company: Union Pacific's Historic Salt Lake Route* (San Marino, Calif.: Golden West Books, 1988), 34–35.

3. David Hirschi, "Governor and Party Visit Zion Canyon," *Washington County News*, October 16, 1913, 1.

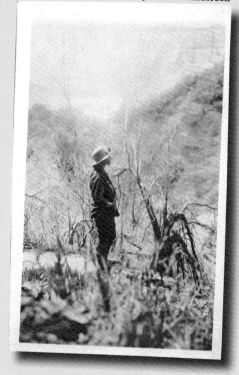

Photo courtesy Barbara Anderson

4. "Little Zion Valley Stage Established," *Washington County News*, January 18, 1917, 8.

5. "To Open Zion Canyon at Early Date," *Salt Lake Herald Republican*, February 17, 1917, 14.

6. Seegmiller, *Selling the Scenery*, 6.

PRETTY-FACE PUBLICITY

1. Thomas G. Alexander, "Red Rock and Gray Stone: Senator Reed Smoot, the Establishment of Zion and Bryce Canyon National Parks, and the Rebuilding of Downtown Washington, D.C.," *The Pacific Historical Review* 72, No. 1 (February 2003): 1–38.

2. "Zion Park Receiving Praise in California," *Washington County News*, January 29, 1920, 1.

3. "Plan Pilgrimage to Zion Canyon," *Salt Lake Herald*, April 16, 1920, section 2, 1.

4. Widtsoe, personal journal, April 17, 1920.

DORA'S DIZZY LIFE

1. "Bad Auto Accident Sunday Evening," *Eureka Reporter*, August 4, 1916, 1, 8; "Case Decided Against Orem Interurban Road," *Eureka Reporter*, March 2, 1917, 3.

2. "Cold Steel for Girl Yeomen," *Salt Lake Herald*, August 16, 1918, 12.

3. "Citizens Join in Celebrating Legion Day," *Deseret Evening News*, June 15, 1920, 12.

4. Whit Burnett, "Art from a Safe Distance," *Salt Lake Herald*, February 11, 1920, 14.

ALL ABOARD

1. Anna G. Widtsoe, personal letter, May 8–16, 1920, Widtsoe Family Papers, 1866–1966, Utah State Historical Society, MSSB92, box 14 folder 2.

2. Ibid.

3. Ibid.

4. Ibid.

5. "Miss Catherine Levering," *Salt Lake Tribune*, June 17, 1923, society, 2.

6. "Cedar," *Parowan Times*, May 18, 1921, 10.

A DESERT PANORAMA

1. Eyre Powell, "Co-eds From Utah University in the First Party to Penetrate Latest Wonderland," *New York Tribune*, June 6, 1920, 7.

2. Widtsoe, personal letter, May 8–16, 1920.

3. "Zion National Park Opens to Girls of 'U,'" *Salt Lake Tribune*, May 23, 1920, automobile section, 1.

4. Ibid.

5. Widtsoe, personal letter, May 8–16, 1920.

6. "Zion National Park Opens to Girls of 'U,'" 1.

7. Widtsoe, personal letter, May 8–16, 1920.

8. "Zion National Park Opens to Girls of 'U,'" 1.

9. Widtsoe, personal letter, May 8–16, 1920.

A FITTING PROLOGUE

1. "Zion National Park Opens to Girls of 'U,'" 1.

2. Widtsoe, personal letter, May 8–16, 1920.

3. "Zion National Park Opens to Girls of 'U,'" 1.

4. "Zion Beckons to Vacationists: Park Open without Ceremony," *Salt Lake Herald*, May 23, 1920, 9A.

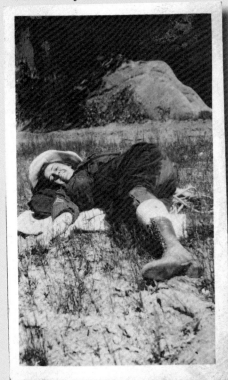

PART 2:
A WEEK IN THE PARK

GIGANTIC GRANDEUR

1. "Zion Beckons to Vacationists," 9A.

2. Widtsoe, personal letter, May 8–16, 1920.

3. Elayne W. Fitzpatrick, "Ladies' Day in Zion," *Salt Lake Tribune*, May 20, 1973, 4H.

4. "Zion National Park Opens to Girls of 'U,'" 1.

5. Widtsoe, personal letter, May 8–16, 1920.

6. Ibid.

WEEPING ROCKS

1. Widtsoe, personal letter, May 8–16, 1920.

2. Ibid.

3. "Informal Opening Zion National Park: "U" Girls Return after Enjoyable Trip," *Deseret Evening News*, May 17, 1920, section 2, 1.

4. Widtsoe, personal letter, May 8–16, 1920.

5. Ibid.

6. Powell, "Co-eds from Utah University," 7.

REACHING NEW HEIGHTS

1. Widtsoe, personal letter, May 8–16.

2. Powell, "Co-eds from Utah University," 7.

3. Ibid.

4. Widtsoe, personal letter, May 8–16, 1920.

SUSPENDED OVER A CHASM

1. Widtsoe, personal letter, May 8–16, 1920.

2. Fitzpatrick, "Ladies' Day in Zion," 4H.

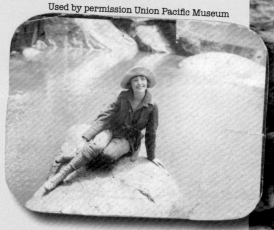

3. Ibid.

RAGING RIVER

1. Powell, "Co-eds from Utah University," 7.

2. Ibid.

3. Fitzpatrick, "Ladies' Day in Zion," 4H.

4. Powell, "Co-eds from Utah University," 7.

GREAT STONE FACES

1. Fitzpatrick, "Ladies' Day in Zion," 4H.

2. Powell, "Co-eds from Utah University," 7.

3. Fitzpatrick, "Ladies' Day in Zion," 4H.

4. Widtsoe, personal letter, May 8–16, 1920.

CANYON TOGS

1. Powell, "Co-eds from Utah University," 7.

SCRAMBLING ON THE ROCKS

1. "Salt Lakers Will Explore New National Beauty Spot," *Salt Lake Tribune*, May 9, 1920, society, 1.

2. Widtsoe, personal letter, May 8–16, 1920.

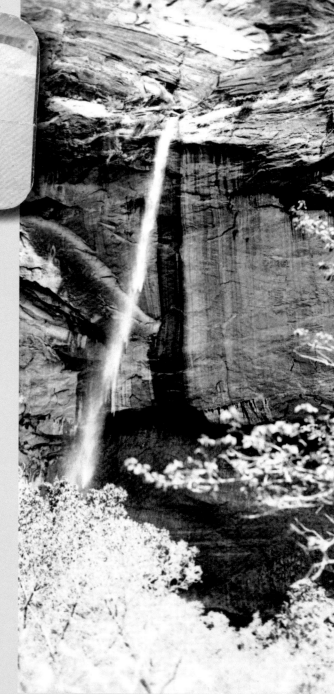

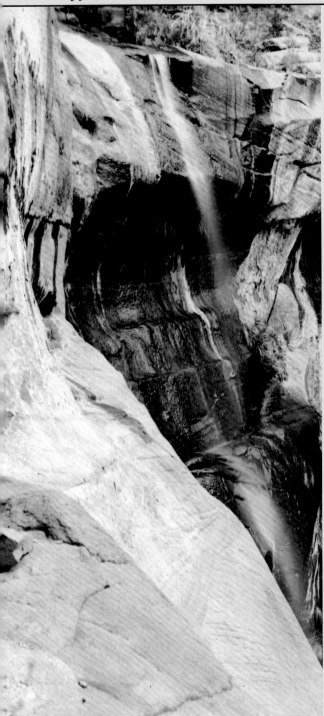

3. United States Railroad Administration, *Zion National Monument Utah* (Chicago: Rathbun-Grant-Heller Co., 1919), 13.

4. Powell, "Co-eds from Utah University," 7.

5. Fitzpatrick, "Ladies' Day in Zion," 4H.

6. Widtsoe, personal letter, May 8–16, 1920.

7. Powell, "Co-eds from Utah University," 7.

HIDE AND SEEK

1. Unknown newspaper clipping in scrapbook.

2. "'U' Girls Explore Zion Canyon: Utah's Wonderland Is Thrilling," *Salt Lake Tribune*, May 18, 1920, 24.

3. "L. A. Girl Saved on Rocky Cliff," *Los Angeles Examiner*, May 24, 1920.

4. "'U' Girls Explore Zion Canyon," 24.

5. *Los Angeles Evening Herald*, May 8, 1920.

MEAL TIME

1. United States Railroad Administration, *Zion National Monument Utah*, 14.

2. Widtsoe, personal letter, May 8–16, 1920.

3. Dora Montague, caption written under photo in personal scrapbook.

CAMPY CAPERS

1. Widtsoe, personal letter, May 8–16, 1920.

AROUND THE CAMPFIRE

1. Author unknown, paper found in Anna Widtsoe's personal journal, Widtsoe Family Papers, 1866–1966, Utah State Historical Society, MSSB92, box 14 folder 2.

2. "Salt Lake Girls Explore Zion Park: First Entrants at Official Opening," *Salt Lake Herald*, May 18, 1920, 9.

DISTINGUISHED VISITORS

1. Peter H. Hassrick et al., *A Century of Sanctuary: The Art of Zion National Park* (Springdale, Utah: Zion Natural History Association), 115.

2. Widtsoe, personal letter, May 8–16, 1920.

3. "Salt Lake Capitalists Visit Utah's Dixieland," *Washington County News*, May 13, 1920, 1.

4. Stephen T. Mather, letter to Lafayette Hanchett, March 3, 1920. Letter in author's collection.

5. "Trade Tour Date Changed to Sept. 8," *Washington County News*, August 26, 1920, 6.

6. "Informal Opening Zion National Park," 1.

Photo courtesy Barbara Anderson

PART 3:
OPENING THE GATE

OPENING DAY

1. "Zion Beckons to Vacationists," 9A.

2. "Informal Opening Zion National Park," 1.

EXPANDING OPERATIONS

1. "Informal Opening Zion National Park," 1.

2. "Railroad Survey Begun," *Washington County News*, July 11, 1918, 1.

3. Signor, *The Los Angeles and Salt Lake Railroad Company*, 87.

4. Lafayette Hanchett, "Record Time Railroad Construction," *Parowan Times*, July 25, 1923, 1.

5. "Railroad Officials Select'g Hotel Sites," *Washington County News*, October 19, 1922, 1.

6. "Opening of Zion National Park a Big Affair," *Garfield County News*, May 22, 1925, 1.

7. Seegmiller, *Selling the Scenery*, 7–9.

DEVELOPING ACCESS

1. "Arrowhead Trail Is a Primary Road," *Washington County News*, December 29, 1921, 1; "May Mean Railroad Extension to Cedar," *Washington County News*, March 30, 1922, 1.

2. "Wesley E. King Is Home from Trip," *Salt Lake Herald*, June 8, 1920, 7.

3. "Utah's Grandeur to Be Shown in Pictures," *Deseret Evening News*, May 7, 1920, 9.

4. "Road Marking to Begin Soon," *Ogden Standard Examiner*, October 7, 1927, 3.

THE FLOOD THAT FOLLOWED

1. "Informal Opening Zion National Park," 1.

Photo courtesy Barbara Anderson

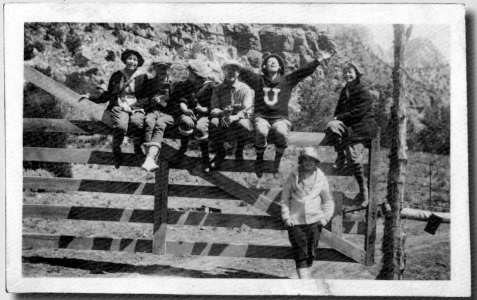

ELIZABETH MILDRED GERRARD

1. *Elizabeth Mildred Gerrard Jenkins*, personal history.

2. "About TAMC," Tripler Army Medical Center, www.tamc.amedd.army.mil.

3. "The American Red Cross Gray Lady Service," American Red Cross Museum, www.redcross.org/museum/history/grayladies.asp.

4. "Death: Elmer and Mildred Jenkins," *Deseret News*, March 7, 1993, metro, B13.

5. *Elizabeth Mildred Gerrard Jenkins*.

6. "Death: Elmer and Mildred Jenkins," B13.

7. Ibid.

Photo courtesy Barbara Anderson

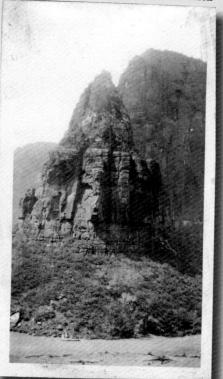

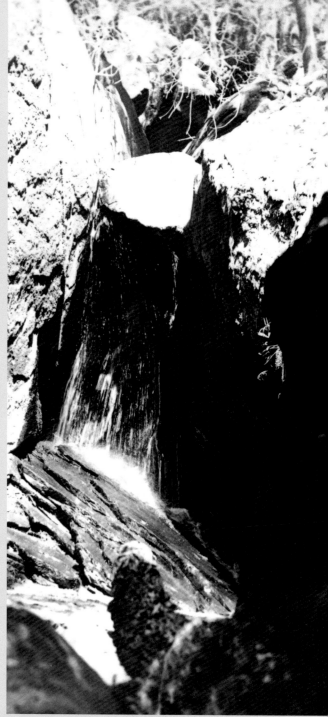

2. "Zion Park Dedicated," *Washington County News*, September 16, 1920, 1.

3. Woodbury, *Southern Utah and Its National Parks*, 203.

4. "Travel to Parks Increased 65 per Cent," *Garfield County News*, October 10, 1930, 1; "Civic Clubs Hold Busy Session at Cedar City," *Parowan Times*, March 1, 1940, 1.

5. "Visits to Zion Park Totaled 2.3 Million in '90," *Deseret News*, January 19, 1991, metro, B2.

BIOGRAPHIES
ANNA GAARDEN WIDTSOE

1. Leah Eudora Dunford Widtsoe, handwritten biography on Anna's first three years, Widtsoe Family Papers, 1866–1966, Utah State Historical Society, MSSB92, box 1 folder 1.

2. *Five Generations of Voting Mormon Women (ca. 1920)*, photo postcard, LDS Church Historical Department, PH 463.

3. "Death: Anne Widtsoe Wallace," *Deseret News*, July 12, 1990, metro, B11.

4. "Newlyweds to Go East Today," *Ogden Standard Examiner*, October 8, 1926, 11.

5. *Biographical Note—The Wallaces*, A Register of the Collection at the Utah State Historical Society, The Widtsoe Family Papers, 1866–1966, Utah State Historical Society.

6. "Death: Anne Widtsoe Wallace," B11.

7. Fitzpatrick, "Ladies' Day in Zion," 4H.

ISADORA (DORA) MONTAGUE

1. "Obituaries: Dora Montague Wareing," *Deseret News*, December 2, 1986, metro, 8D.

2. Barbara Anderson, telephone interview with the author, June 12, 2009.

3. "Obituaries: Dora Montague Wareing," 8D.

4. Anderson, telephone interview.

Used by permission Union Pacific Museum

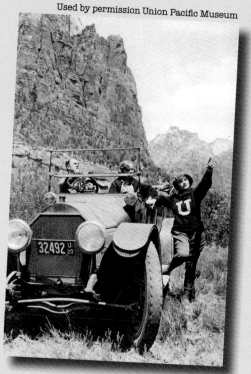

AGNESS ELLEN (NELL) CREER

1. Agness Ellen Creer, *James Miller Family History* (Spanish Fork, Utah: J-Mart Pub., 1967), 105.

2. Merle Hobbs Casper, personal interview with the author, April 21, 2009.

3. Creer, *James Miller Family History*, 106.

CATHERINE ALICE LEVERING

1. Unknown newspaper clipping in scrapbook.

2. *R. L. Polk & Co's Salt Lake City Directory 1911 vol. XX* (Salt Lake City, Utah: R. L. Polk & Co. of Utah, 1911), 623.

3. "Skelton's Pupils in Recital," *Salt Lake Telegram*, December 9, 1917, 16.

4. "Calendared Social Events," *Salt Lake Telegram*, May 3, 1919, 16.

5. "Triumph Is Scored at Sorority Vaudeville," *Utah Chronicle*, March 24, 1919, 3.

6. "What Society Hears Over the Teacups," *Salt Lake Telegram*, June 14, 1919, 16.

7. "Miss Catherine Levering," *Salt Lake Tribune*, June 17, 1923, society, 2.

8. "Opens Studio," *Nevada State Journal*, May 17, 1931, 5.

9. "Peabody Institute," Wikipedia, http://en.wikipedia.org/wiki/Peabody_Institute.

10. "Opens Studio," 5; "Miss Catherine Levering," 2.

11. "Opens Studio," 5.

12. "Violin Students of Modern School Heard in Recital," *Salt Lake Tribune*, February 28, 1932, D7.

13. "Weddings in State," *Salt Lake Tribune*, June 11, 1933, 6E.

14. "Last Rites for Joseph Fisher," *Oakland Tribune*, November 29, 1946, 10.

15. "Divorces Filed," *Oakland Tribune*, November 5, 1961, 34.

16. "Last Rites for Joseph Fisher," 10; "Sweet Notes for Musicians," *Oakland Tribune*, March 27, 1973, 32; Catherine Bjelke Manzer, "California Death Index, 1940–1997" [database online]. Provo, UT, USA, Ancestry, www.ancestry.com

MELBA VICTORIA DUNYON

1. *Men of Affairs in the State of Utah* (Salt Lake, Utah: The Press Club of Salt Lake, 1914).

2. "Salt Lake Society," *Ogden Standard Examiner*, December 2, 1923, 10.

3. Jocelyn Reed, personal letter to the author, September 9, 2009.

KNOWN NEWSPAPERS THAT RAN STORIES ABOUT THIS TRIP

NEWSPAPER	CITY/STATE/COUNTRY
Ada Evening News	Ada, OK
Boston Post	Boston, MA
Buffalo Courier	Buffalo, NY
Charlston Daily Mail	Charlston, WV
Chicago Herald and Examiner	Chicago, IL
Coshocton Tribune	Coshocton, OH
Deseret Evening News	Salt Lake City, UT
Eau Claire Leader	Eau Claire, WI
Hamilton Evening Journal	Hamilton, OH
Janesville Daily Gazette	Janesville, WI
Logansport Pharos-Tribune	Logansport, IN
Los Angeles Evening Herald	Los Angeles, CA
Los Angeles Examiner	Los Angeles, CA
Los Angeles Sunday Times	Los Angeles, CA
Mountain Democrat	Placerville, CA
New York Times	New York, NY
New York Tribune	New York, NY
Oakland Tribune	Oakland, CA
Ogden Standard-Examiner	Ogden, UT
Piqua Daily Call	Piqua, OH
Pittsburg Leader	Pittsburgh, PA
Portsmouth Daily Times	Portsmouth, OH
Reno Evening Gazette	Reno, NV
Salt Lake Herald	Salt Lake City, UT
Salt Lake Tribune	Salt Lake City, UT
Washington County News	St Geroge, UT
Weekly Dispatch	London, England

Lake Herald

Local Min...

TAH, TUESDAY MORNING, MAY 18, 1920

GREEMENT IS D...

Salt Lake Girls Explore Zion Park

First Entrants at Official Opening

SALT LAKE girls are first tourists through the gateway of Zion National park on the day of it's official opening for visitors. Going through is Miss Catherine Levering, prominent young Los Angeles dancer, formerly a Salt Lake girl. Observing her on from the top of the gate are the maids of the University expedition who explored the innermost stretches of the Utah wonderland previous to the opening. They are Misses Ann Widtsoe, Mildred Gerrard, Nell Creer, Melba Dunyon and Dora Montague.

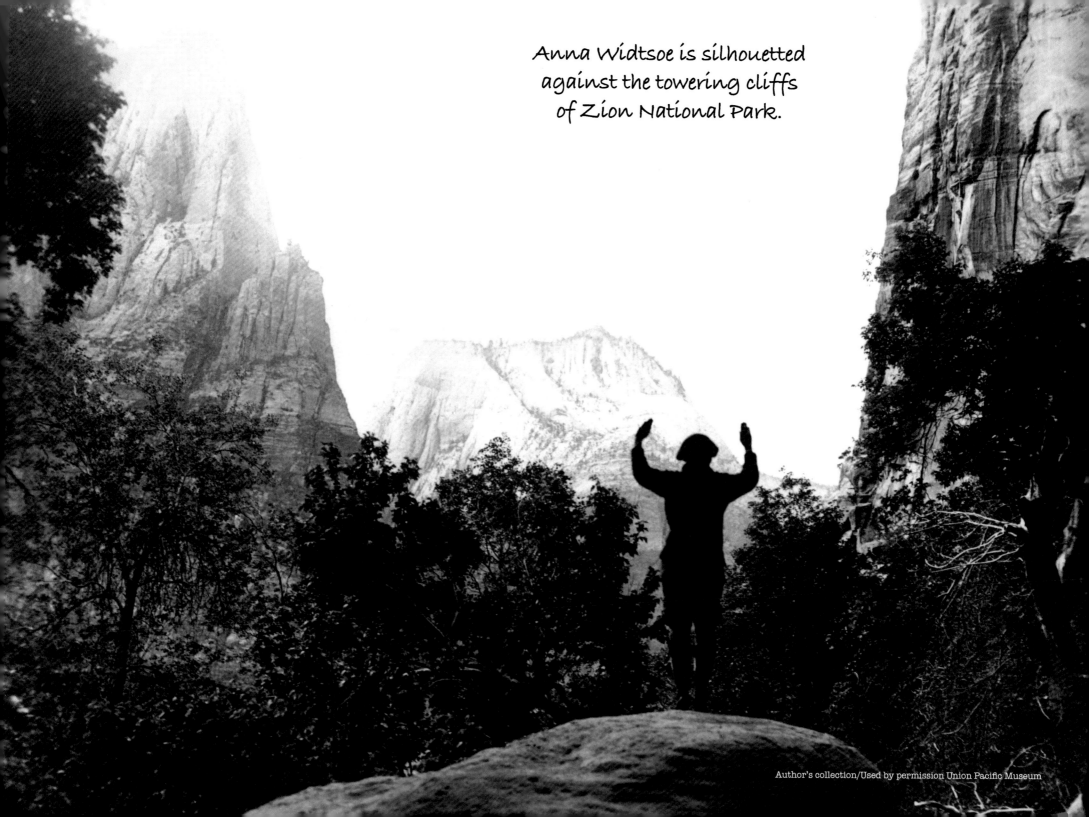

Anna Widtsoe is silhouetted
against the towering cliffs
of Zion National Park.

Utah Department of Transportation

Left, modern Utah road map shows relationship between Lund, Cedar City, and Zion National Park. Above, the lonely road to Lund. Right, Lund is little more than a ghost town today.

Photo by Melissa Clark

Above, Wylie Camp was located directly south of the cabins by Zion Lodge. The area is occupied in part by a parking lot today. Left, *Restful Interlude* by Melissa Clark was featured in the book *A Century of Sanctuary: The Art of Zion National Park*.

ABOUT THE AUTHORS

JOHN CLARK graduated from Utah State University with a BFA in graphic arts and advertising in 1994. He is currently the associate art director for the *Deseret News* in Salt Lake City, and he writes a series on automobile history in Utah called *Motor Tales*. John is an accomplished block-printing artist whose work has been displayed in numerous juried art shows across Utah. He is currently serving as the president of the Utah Chapter of the Lincoln Highway Association and is a member of the Zion Natural History Association. John also designed Utah's newest ski-themed license plate.

MELISSA CLARK earned a BA in classical civilization at Brigham Young University in 1992. While caring for their three children, Melissa dove into the artistic pursuit of *scherenschnitte,* or paper cutting. Her artwork was included in the art exhibition, "A Century of Sanctuary: The Art of Zion National Park" in 2008, and was featured on the cover of the Zion Canyon Field Institute's class catalogue for the 2009 season. She enjoys traveling the back roads of Utah with her husband, John, in search of Utah's past.

Scott G. Winterton, Deseret News

Notes from my trip to Zion:

My photos of Zion.

My photos of Zion.

My photos of Zion.

My photos of Zion.